How To Paint With
ACRYLICS
ALWYN CRAWSHAW

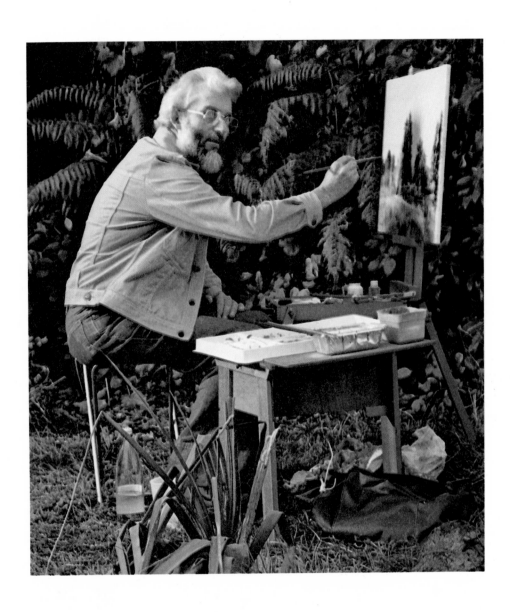

HPBooks

Published in the United States by
HPBooks
P.O. Box 5367
Tucson, AZ 85703
602/888-2150

Publishers: Bill and Helen Fisher
Executive Editor: Rick Bailey
Editorial Director: Randy Summerlin
Art Director: Don Burton

First Published 1979 by
Collins Publishers, Glasgow and London

ISBN 0-89586-158-5
Library of Congress Catalog Card Number: 81-85411

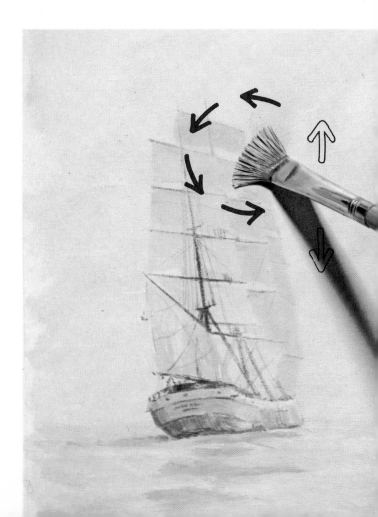

CONTENTS

Portrait Of An Artist— Alwyn Crawshaw

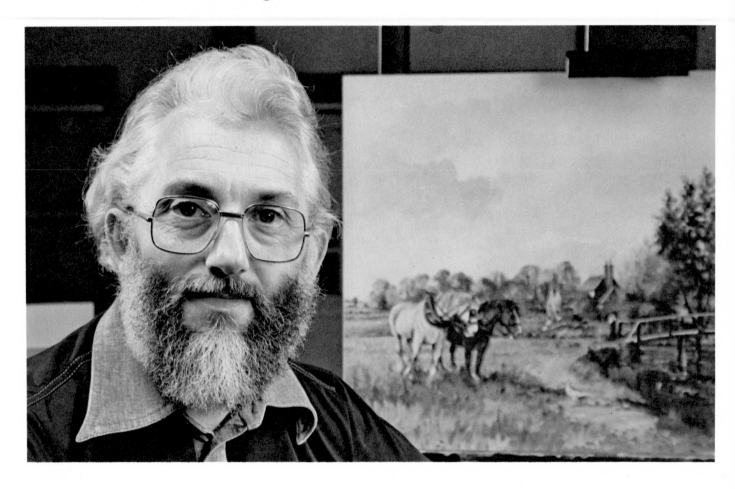

Alwyn Crawshaw was born in 1934 at Mirfield, Yorkshire, England. He now lives in Surrey. During his earlier years, he studied watercolor and oil painting. Now he's considered a leading lecturer, author and painter in acrylics. His work has brought him recognition as one of the leading authorities in his field.

Crawshaw paints what he calls *realistic subjects*. These include many English landscape scenes.

His work has received critical acclaim. In most of Crawshaw's landscapes there is a distinctive trademark—usually elm trees or working horses.

Crawshaw's work became popular after his painting *Wet and Windy* was included in the top 10 prints chosen by members of the Fine Art Trade Guild in England in 1975. Fine art prints of this painting are still in demand throughout the world.

Another now-famous painting was completed during Queen Elizabeth's Jubilee Year in 1977. Crawshaw wanted to record an aspect of Britain's heritage. He completed *The Silver Jubilee Fleet Review 1977* after long research and many hours working at the location. A section of the painting is shown on the opposite page.

Crawshaw has been a frequent guest on radio talk shows in England. He demonstrates his techniques to members of many art societies in the United Kingdom.

His paintings are on exhibit throughout the world.

Crawshaw has exhibited in one-man shows at the art gallery of Harrods Department Store in London. Another one-man show was opened by the Duchess of Westminster, who now has a Crawshaw painting in her collection. Crawshaw is also the author of

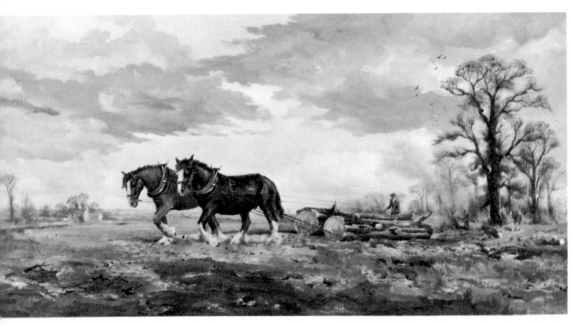

Crawshaw's painting **Wet And Windy** was voted among the top 10 prints chosen by the Fine Art Trade Guild in 1975.

another HPBooks art book, *How To Paint With Watercolors.*

Exhibitions of his work draw an enthusiastic audience. There is an air of reality about his work, an atmosphere that is appealing.

Alwyn Crawshaw is married and has three children—two teen-age daughters and a younger son.

On weekends or holidays, a sketching day frequently turns into a family outing.

There are two attributes necessary for artistic success, according to Alwyn Crawshaw: *dedication* and a *sense of humor.* The need for the first is self-evident. The second "helps you out of many a crisis."

The Silver Jubilee Fleet Review 1977

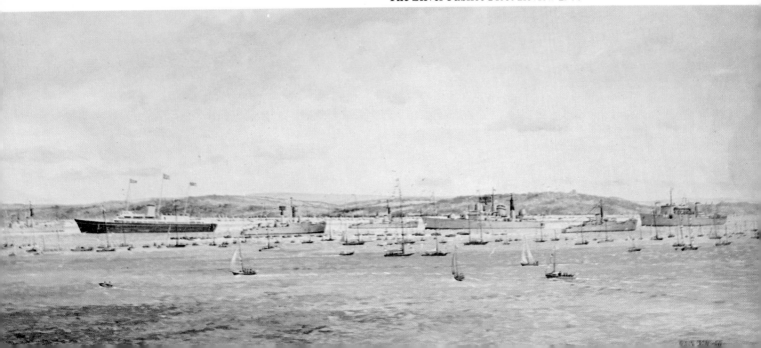

Why Paint?

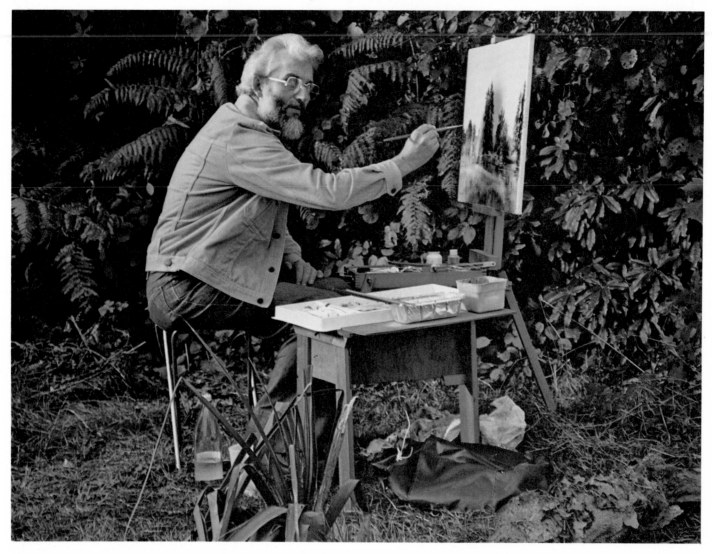

Painting is one of man's earliest and most basic forms of expression. Stone Age men drew on cave walls. These drawings were usually of wild animals and hunting scenes.

Stone Age artists must have been creative and dedicated. There was no local art shop to help them with materials and no electricity to brighten dark days.

Cave art started more than 25,000 years ago. Painting is still with us today and has become sophisticated. It has survived thousands of years of changing civilizations, styles, ideas and techniques.

Art materials have undergone vast changes. The wide range of media and equipment now available—plus the variety of methods that are taught—can make painting frightening for the beginner. People can be put off by not knowing where or how to start.

I often hear people express a desire to paint. They usually say they have never tried and don't know where to begin.

How can people say they can't paint when they have never tried?

Let me try to clear your mind about some of the *mysteries* of painting, from the beginner's point of view.

You may feel intimidated by the volume of art that has been created over the past thousands of years. There are hundreds of styles and techniques, from painting on ceilings to painting miniatures.

Author Alwyn Crawshaw is shown here painting in his studio. He will guide you step by step as you experiment with the styles and techniques of acrylic painting.

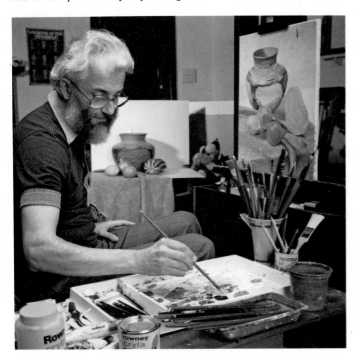

You may be confused by names such as *Prehistoric, Byzantine, Gothic* and *Florentine* art, *Impressionism, Surrealism, Abstractionism, Cubism* and so on. All these terms boggle the mind. To unravel them all and understand the differences could take a lifetime.

Then where do you start? The simplest answer is temporarily to disregard all you have learned. Start from the beginning, like the Stone Age men.

Today, most people who want to paint have one thing in common—a *creative instinct.* Unfortunately, some people don't realize this until later in life, when something stirs within them or circumstances lead them to painting.

For some, painting becomes a fascinating and relaxing hobby. For others, it becomes a way of expressing inner thoughts. For house-bound people, painting can be therapeutic.

People can meet and make friends by joining art societies or by selling their art at local shows or in galleries.

I think painting is a creative way to express your feelings. You can forget all your immediate troubles and produce a work of art to share and enjoy with others.

You are taking your first big step by reading this book. This means you are curious about painting and want to learn about it.

You have selected a medium: *acrylics.* Now you are ready to learn about painting with acrylics as a new technique.

Let's start at the beginning. I will take you through this process step by step, working simply at first. Then we will progress to more advanced techniques.

If you have some acrylic paints, the most difficult thing to do at the moment will be to continue reading. Your desire to try out the paint will be stimulated by looking through the book. Leave the paints alone for the moment. Note the color illustrations and different methods of working. Relax before you go on.

When you start the lessons and exercises, enjoy them. You may find some parts difficult. Don't become obsessed with the problem. Go to the next stage and then come back. Look at the problem with a fresh eye. That will make it easier to solve.

Understanding Acrylics

Why use acrylic paints? I am constantly asked this question. The quick answer is that I *like* using them. They suit my personality.

Why do acrylics suit my personality? I believe a painting comes from "inside" the artist. This origin gives the painting mood or atmosphere, the quality that makes it look lively.

Acrylic colors have an advantage of consistency. They can be used thickly or thinly—even as thin and diluted as watercolors. Acrylics come from the tube with a buttery consistency similar to oil paint. Paintings can be built up thickly in relief—which is called *impasto*. One advantage of acrylics used this way is quick drying time, only a few hours. Oil paints can take months to dry.

Because of acrylic's thick or thin consistency, you have the choice of using a palette knife or a brush for painting.

Palettes are available that will keep the paint wet almost indefinitely. These palettes have been a great breakthrough, because they save a lot of paint that was once wasted by drying too soon.

The quick drying quality of acrylics can be a great artistic advantage. As one stage of a painting is completed, you can overpaint immediately without disturbing paint underneath. That's why you can keep working while your inspiration is fresh. If circumstances permit, you can start a painting in the morning and finish it in the afternoon.

If you like details in a picture, you can put them in when necessary. The paint will dry quickly so you can work on top of the previous layer. This rapid painting capability allows you to maintain your initial feeling for the painting. Most often the whole picture can't be finished at one sitting. But certain passages can at least be worked up to your requirements without being delayed by long drying time.

Painting with acrylics is a direct way of painting and one of the reasons why it suits me.

The photograph at right illustrates an exercise showing the versatility of acrylic paints. Starting at the bottom, there is a delicate, thinned watercolor treatment. Next is flat paint, followed by a regular-thickness application of pigment. At the top is acrylic

Here are the results of various kinds of acrylic paints: at the top, the paint is mixed with texture paste for maximum thickness. Next, regular-thickness paint is shown. The third area shows acrylic color painted flat. The bottom area shows how a thin watercolor technique can be achieved with acrylics.

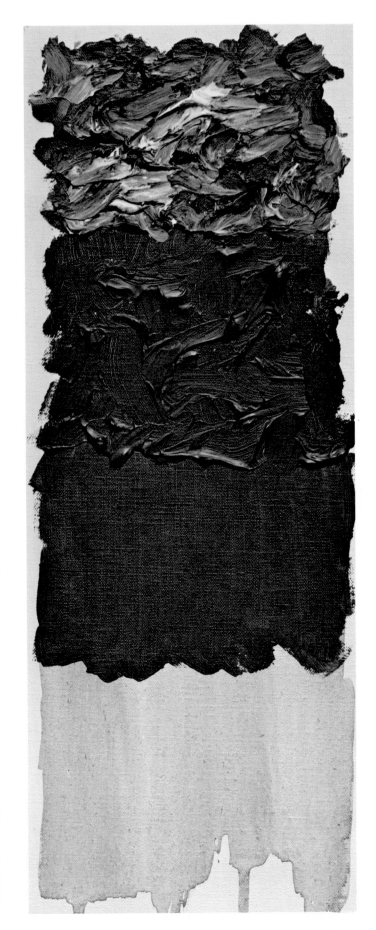

color with texture paste added as a thickener to get the ultimate relief effect.

Acrylics come in tubes. Always put the cap back on or the paint will dry in the tube. Mix acrylic paints with water— *not white spirits or turpentine*—and wash brushes in water. Acrylic paints produce no lingering odor.

Keep nylon brushes in water all the time when not painting. I have brushes that have lived in water for seven years, and no harm has come to them. None have ever become hard because of drying paint. If by accident you let a brush get hard, soak it overnight in *methylated spirits.* Then work it between your fingers and wash it out in soap and water. If you use *sable brushes,* never leave them in water for long periods—wash and dry them immediately after use.

When you finish using a brush, put it back in the water. Do this even if you know you will need it again in a few minutes.

When you take the brush out of the water to use it again, dry it well on a rag. Keep clean rags handy at all times for this purpose. Use only a damp brush when working normally, because the acrylic's own wet consistency is all you need.

When you squeeze paint onto the palette, always put the colors in the same position. This is important discipline. The reason is simple: The way you pick up colors from your palette must become second nature. You don't want to have to search for a particular color.

The photograph on page 11 shows the order I lay out colors on my palette. There is no magic about the way these are placed. I started using this order at art school, and I have continued using it.

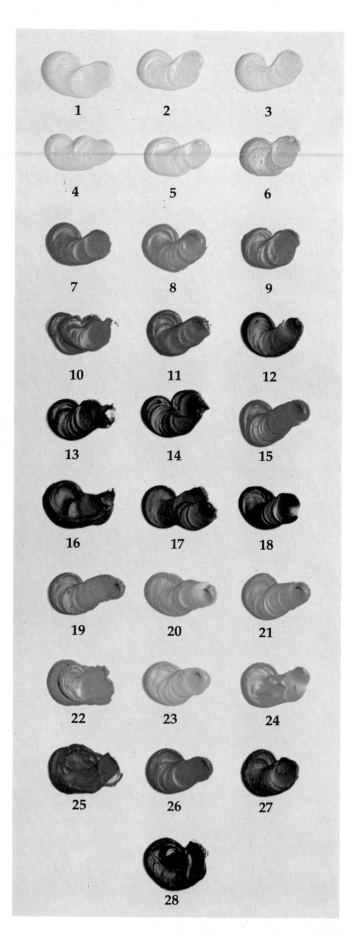

Because this color arrangement works well, you may want to adopt it. I normally use these 10 colors. The photograph at left illustrates a range of additional available colors.

You may want to use a palette designed to keep paints moist indefinitely. If not, use a glass or plastic surface, or even a dinner plate for mixing colors. Paint will start to dry while you are working. Don't put out more paint than you can use at one sitting, unless you are using the special palette.

Acrylic paints are made with the same natural pigments used in oil paints. Instead of being bound in oil, as oil paints, or in water-soluble gum, as in watercolors, these pigments are mixed in a watery binder of *acrylic polymer resin.*

1. **Primrose**
2. **Cadmium yellow pale**
3. **Lemon yellow**
4. **Permanent yellow**
5. **Cadmium yellow deep**
6. **Cadmium orange**
7. **Vermilion**
8. **Cadmium scarlet**
9. **Cadmium deep red**
10. **Permanent rose**
11. **Red violet**
12. **Deep violet**
13. **Permanent violet**
14. **Indanthrene blue**
15. **Cobalt blue**
16. **Monestial blue**
17. **Monestial green**
18. **Hooker's green**
19. **Opaque oxide of chromium**
20. **Pale olive green**
21. **Emerald**
22. **Turquoise**
23. **Yellow ochre**
24. **Golden ochre**
25. **Burnt sienna**
26. **Venetian red**
27. **Transparent brown**
28. **Black**

Such resins are the product of modern chemistry. They are familiar to most people in the form of transparent plastics. The term *polymer* means the joining of small molecules called *monomers* into long chemical chains that form plastic materials. These resins are converted into milky white, water emulsions that dry as a clear film when the water evaporates. The emulsions are versatile adhesives. Combine them with permanent, artist-quality pigments and you have a permanent pigment encased in a tough coating that does not deteriorate, yellow or become brittle.

Acrylic paintings can be cleaned by gentle sponging with soap and water.

A Cerulean blue
B Bright green
C Burnt umber
D Raw umber
E Cadmium yellow
F Cadmium red
G Crimson
H Ultramarine blue
I Raw sienna
J White

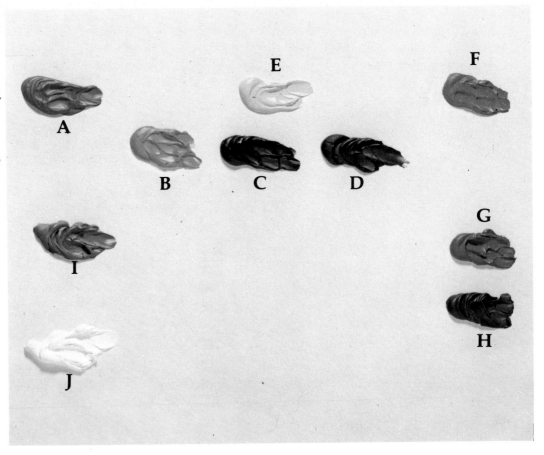

Equipment

Equipment for painting with acrylics can vary from basic essentials to a roomful of easels, boards, canvases, brushes and so on. Some painters collect too many brushes. There's nothing wrong with a lot of brushes. I have more than I will ever use, but I enjoy knowing that somewhere I have a brush for the job. Anything beyond basic equipment is an individual choice.

The photograph on the opposite page shows the work table in my studio. It is intentionally overcrowded to show art materials in a working environment and to suggest how to set up your equipment. The diagram below identifies the equipment.

Brushes are the tools of the trade. They are the instruments with which you create shapes and forms on your canvas. They are the most important equipment you will ever buy.

Purchase the best quality brushes you can afford. The brush allows your skills to be expressed and seen. Never treat a brush as a showpiece when you work with it. The brush has to perform different movements and accomplish different shapes and patterns. If it means you have to push the brush against the direction of the bristles, then do it. You will gradually learn to use your brushes for certain types of work. You will get to know them and be able to get the most out of your painting.

Three different series of nylon brushes and two watercolor brushes that I use are shown on page 14. The nylon brushes in the center photograph hold

A **Canvas**
B **Easel**
C **Wooden mannequin**
D **Water container**
E **Brush tray**
F **Brushes and brush holder**
G **Pencils**
H **Varnish brush**
I **Gloss medium**
J **Primer**
K **Palette knives**
L **Erasers**
M **Mat medium**
N **Gel retarder**
O **Acrylic paint tubes**
P **Paint rag**
Q **Drawing board and paper**
R **Palette**

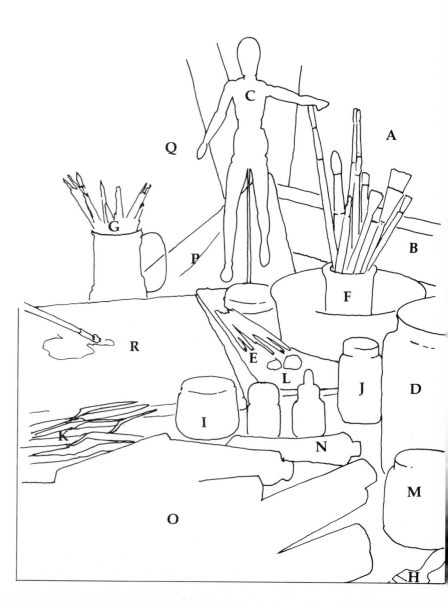

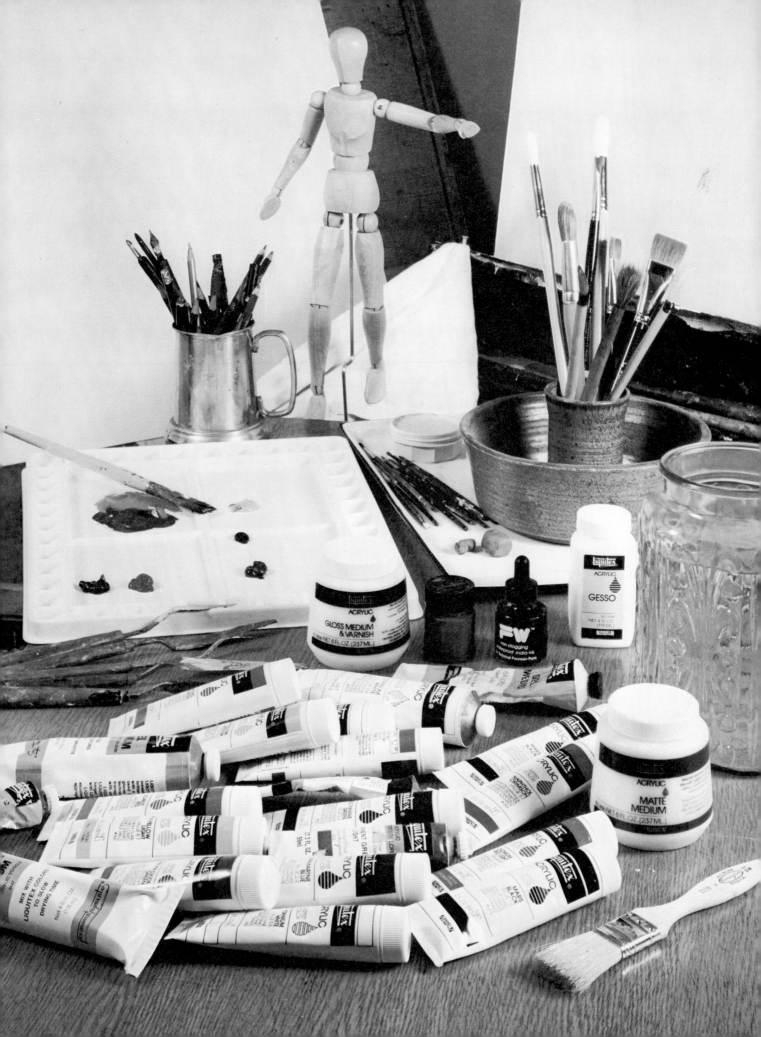

less paint than the ones in the right photograph. I use the white nylon brushes at left in place of sable brushes when I want to be rougher with them. I use sable brushes in sizes No. 1, 2 and 3—shown at bottom left—for fine line work, and No. 3, 4 and 5 on the right for larger, delicate work.

Some artists prefer to use a palette knife instead of a brush. Never use a palette knife too roughly. You can put a nick in it or catch it in the canvas and flick paint everywhere. Three knives are illustrated on the opposite page.

Canvas, wood, heavy writing paper, brown paper—all can be used as surfaces for acrylic painting. A drawing board is useful to support the painting surface.

Three easels are illustrated on the opposite page. Easels are not essential for small paintings if you are working on paper pinned to a drawing board. But the small table easel is ideal if you want your board at an angle on the table. The large studio easel is essential for large paintings because the surface must be held firm. The easel on the right is a portable one for outdoor use. It folds down and converts into a carrying box for paints and a canvas up to 27 inches deep. It can also be used inside as a permanent paintbox.

I keep my brushes in an old refrigerator tray. It is long and flat and has been the permanent home for my brushes for many years. When I conduct painting demonstrations, I use an aluminum container that is as efficient. There are also special containers on the market for holding brushes in water.

Retarder is very useful to have when painting large areas in the wet-on-wet technique. This mate-

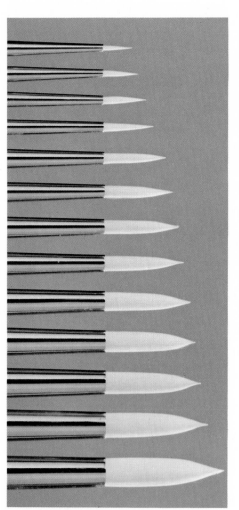

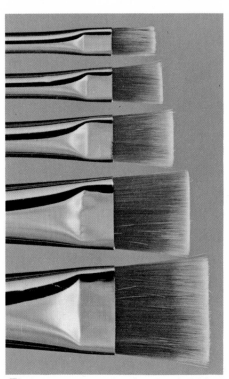

These common square brushes hold less paint than other brushes.

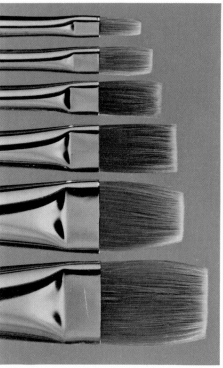

This brush shape has uses similar to square brushes.

Round nylon brushes are often used in place of sable brushes. Nylon stands up to tougher treatment.

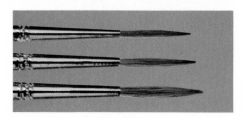

Thin sable brushes are used for fine-line work.

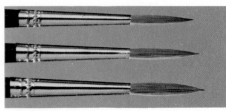

These sable brushes are used for larger, delicate work.

rial is described more in the section on basic techniques. Acrylic primer is used for surfaces that are porous. Texture paste helps build thick, rough surfaces when needed. You will need a water jar for washing out brushes. Any kind of jar will work. Finally, you need HB and 2B pencils and an eraser.

The following is a basic equipment list for the exercises in this book. As you gain more confidence, you can add to the equipment.

- **Set of 10 acrylic colors—as described on page 11.**
- **Flat nylon brushes, Nos. 2, 4, 8, 12**
- **Round nylon brush, No. 1**
- **Longhair sable brush**
- **Designer brush, No. 5**
- **Palette, drawing board, brown paper, heavy white writing paper, brush tray, acrylic primer, water jar, HB and 2B pencils and an eraser.**

Below are various palette knives. They can be used instead of brushes for painting. At right are three types of easels: a small table easel, a large, radial studio easel and a portable, folding easel that converts to a carrying box for paint and canvas.

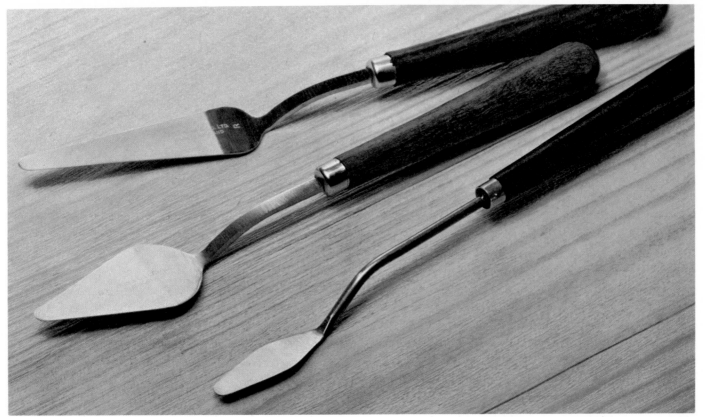

Start Painting

Experimenting With Acrylics

Now you can begin. Many people who have not painted before find this the most difficult bridge to cross—to actually put paint on paper.

We are all self-conscious when doing things we have never tried before. Don't be shy or reluctant when it comes time to paint. You have to begin somewhere.

It's human nature to strive to do better. If we try to run before we can walk, problems arise. So, start at the beginning and take things in a steady, progressive order.

Colors will be the first step. You may find the hundreds of colors overwhelming. But the choice can be simplified.

There are only three basic colors: *red, yellow* and *blue*. These are called *primary colors*. They are illustrated at right, along with three additional colors and white.

All other colors and shades of color are formed by a combination of the three primaries.

In painting, there are different red, yellow and blue pigments that can help recreate Nature's colors. Look at the illustration. I have chosen two reds, two yellows and two blues to illustrate primary colors. These colors are the ones I use for all my acrylic painting.

Before you start mixing colors, use a piece of brown paper to experiment with paint. See what it

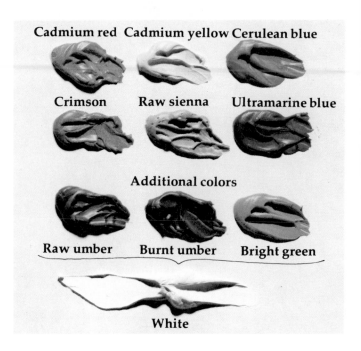

Cadmium red Cadmium yellow Cerulean blue

Crimson Raw sienna Ultramarine blue

Additional colors

Raw umber Burnt umber Bright green

White

feels like. Try different brushes. Use your fingers or a palette knife. Add more water or use less water and see what happens. You'll end up with a strange-looking piece of painted paper, but you will have experienced the *feel* of acrylic paint.

The paint, brushes and paper aren't strangers to you anymore. You have given it a good beginner's try. You will be confident in tackling the next section.

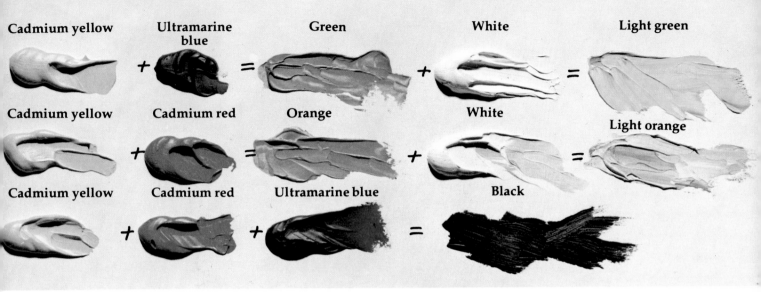

Cadmium yellow		Ultramarine blue		Green		White		Light green
	+		=		+		=	

Cadmium yellow		Cadmium red		Orange		White		Light orange
	+		=		+		=	

Cadmium yellow		Cadmium red		Ultramarine blue		Black
	+		+		=	

Mixing Colors

As we progress through the exercises, practice mixing different colors.

Look at the illustration above. I have taken primary colors and mixed them.

In the first row, cadmium yellow mixed with ultramarine blue makes green. Add white to get light green. In the second row, cadmium yellow mixed with cadmium red makes orange. To make the orange look more yellow, add more yellow than red. To make it more red, add more red than yellow. Add white to make light orange.

My colors do not include ready-made black. Some artists use black and others don't. I don't because I believe it is a "dead" color—too flat. I mix my blacks from primary colors.

Practice mixing different colors on white paper. Mix colors on your palette with a brush. Then make strokes on paper. Don't worry about shapes at this stage—concentrate only on colors.

Experiment and practice. Look around you. Pick a color and try to match it by mixing your acrylic paint.

When there are only three basic colors, it is the *amount* of each color that is important. You can easily mix a green, as shown above. But if it is to be a yellowish green, you have to experiment on your palette. Mix and work in more yellow until you produce the color you want.

This lesson of mixing colors is one that you must practice and improve during all your artistic life. I am still practicing.

Painting Shapes

You must learn to control the paintbrush. When you know how, it is easier than you had thought.

Good control is required when painting edges of areas to be filled in with paint. An example is the circle and rectangle as shown below.

Take a coin or something with a round, flat shape. Trace it with an HB pencil. Do this on plain white paper or brown paper.

Use your small sable brush with plenty of water. With sable brushes, you need *watery* paint so the paint will run out of the brush. When you use nylon brushes, just dampen the bristles. When you fill in the circle, start at the top and work down the left side to the bottom, as shown. Let the bristles *follow*

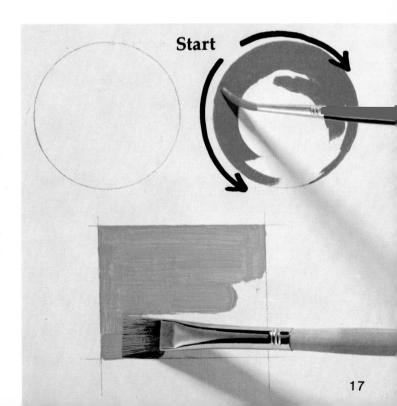

Start

the brush. Pull the brush down. Try to do this in two or three movements.

You can see the pencil guideline as you paint the left side. Turn the paper upside down and continue painting with the visible lines on your left. You can't turn your surface when working on a large painting, so practice until it doesn't feel awkward.

Let's go on to straight lines. This time, draw a box. Do this freehand without tracing.

Here is an *important* rule: When you draw straight lines—unless they are short—always *move your wrist and arm,* not your fingers.

Try this exercise with a pencil. First, draw a straight line downward, moving only your fingers. You can draw only a few fractions of an inch before your fingers make the line bend.

Now do the same exercise with your fingers firm, moving only your wrist and arm. Bend your arm at the elbow. The result will be a long, straight line. Paint the box edges with a small sable or flat nylon brush. Experiment with the small flat brush until you can handle it well. Finish painting the rectangle.

Create other shapes and fill them in. Mix your own colors. Choose any color, perhaps the color of your carpet or a cushion. Try to mix a color similar to it for painting the shapes. You are practicing what you have learned in one exercise. Do this often. Enjoy it and keep practicing.

Perspective Drawing

The ability to draw must come before painting. Take time to practice simple *perspective drawing.*

If you don't think you can draw, this exercise shouldn't worry you. Some artists can paint a picture but would have difficulty doing it as a *drawing.* Colors, values and shapes of masses are what make a painting.

For centuries, artists have invented and used drawing aids. There is a simple, effective aid to drawing, called a *Perspectograph,* on the market. It determines perspective lines for you. But it isn't too difficult to learn perspective without aids.

When you look out to sea, the horizon will always be at your *eye level.* This is true even if you climb a cliff or lie flat on the sand.

There is no actual horizon if you are in a room. But you still have an eye level. It is referred to as the *horizon line.* To find this line, hold your pencil horizontally in front of your eyes at arm's length. Your eye level and horizon line is where the pencil crosses the opposite wall.

If two *parallel* lines were marked on the ground and extended to the horizon, they would appear to come together. Their meeting point is called the *vanishing point.* This is why railway lines *appear* to become closer together and finally meet in the distance. They have converged at the vanishing point.

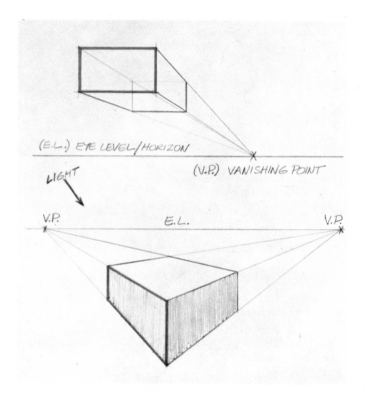

(E.L.) EYE LEVEL/HORIZON

LIGHT

(V.P.) VANISHING POINT

V.P. E.L. V.P.

Look at the rectangular boxes on the opposite page. I drew lines to represent the eye levels.

Near the right end of the first eye level, I marked the vanishing point. I drew a line with a ruler from each of the four corners of the box, all converging at the vanishing point. This gave me the two sides, the bottom and top of the box.

The effect is that of a *transparent* box drawn in perspective. The view is from below the box because the eye level is low.

In the second box, I have shaded the rectangles with pencil to show the light direction. The angle of the box requires two vanishing points, one for each side. Draw this box and paint it as you did for the shapes exercise.

This is a simple exercise. But it is one of the most important. You are creating the *illusion of depth, dimension* and *perspective*. The final box appears to be a three-dimensional object.

At right, study the method of painting the green surfaces of the box. First, paint the box in bright green. Then paint the two sides with a mixture of bright green and burnt umber. Finally, paint the darker, shadowed side with bright green and burnt umber, adding a little ultramarine blue.

When you first painted the box, it looked flat like a silhouette. This was because there was no light or shade—light against dark. Light colors against dark colors enable us to see objects and understand their

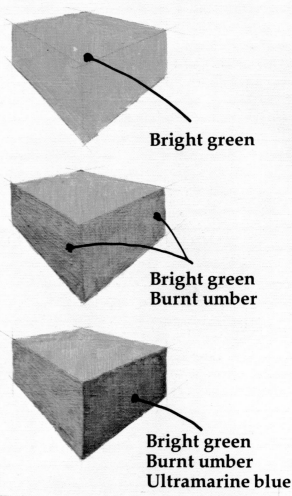

Bright green

Bright green
Burnt umber

Bright green
Burnt umber
Ultramarine blue

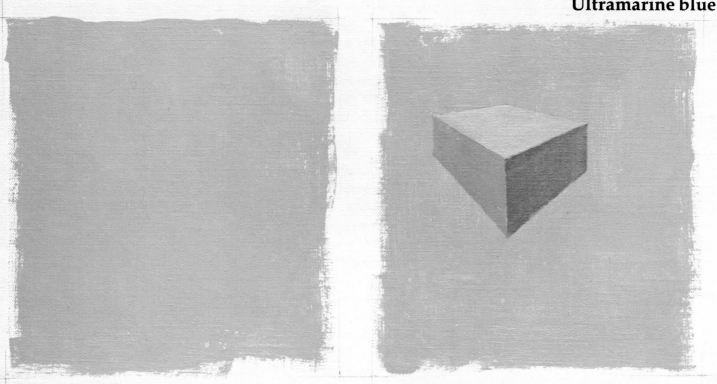

form. A blue box against a background of the same blue, without light or shade, looks like the plain blue patch at the bottom of page 19. With light and shade added, it looks like the blue box shown beside it. Be aware of light against dark whenever you paint.

Look at scenes through half-closed eyes when you paint. The lights and darks become exaggerated, and the middle values tend to disappear. Squinting gives you simple, contrasting shapes to follow. As I said earlier, you do not have to be a perfect draftsman to be able to paint. If you want to enjoy painting, then don't let drawing deter you. Visit exhibitions by a number of artists and you will see a range of different types of painting. Some are detailed, others are almost flat areas of color.

Next time you are in the countryside, look at a scene and squint your eyes. You will see definite shapes that you can easily draw. You will see light areas against dark ones. Painting that particular scene will be easier than you had estimated.

Below is a pencil drawing of a landscape. At bottom you can see how I kept the shapes simple when I painted it. This simplicity of shapes is what you should strive for at this stage.

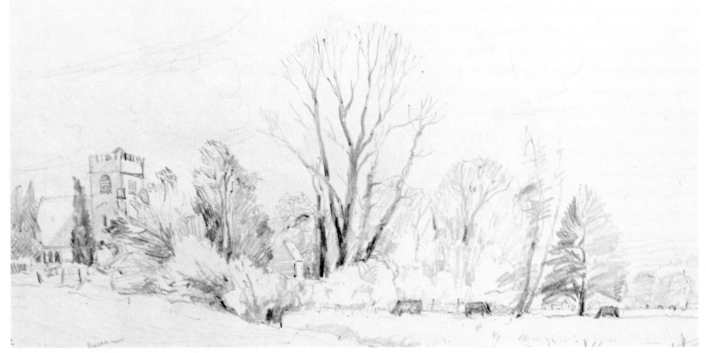

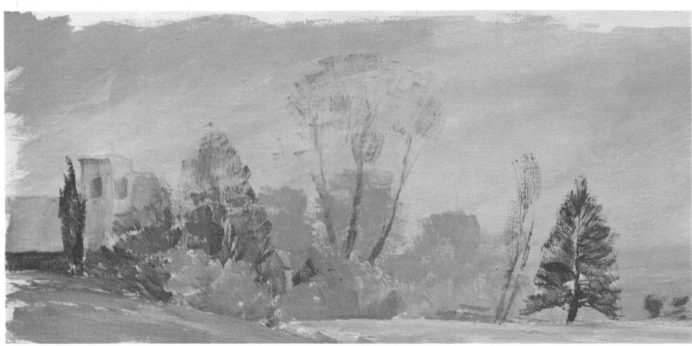

Painting Simple Objects

If you have practiced mixing colors and drawing, you shouldn't have much trouble copying the objects I have drawn for this exercise. Or find your own objects to paint.

Start by copying the illustrations. You may feel more familiar with the object if you paint it first from the book. Then you won't have to worry about problems drawing a real object. When you have copied from the book, get the object, set it up and draw it from the real thing.

Treat these simple objects broadly, without worrying about detail. Remember the guideline: When painting from life, squint to see the forms and light and dark areas. This helps simplify the complicated shapes.

Try to paint directly in these exercises. Attempt the first time to get the color you see on paper. These exercises are not meant to test your skill at details but to give you experience in painting a whole picture. They will help you observe shapes and values and apply on paper what you see. This lesson emphasizes use of different supports or sur-

faces on which to paint. Let's first use heavy white paper.

The first object is a brick. Paint the background. Then paint the brick in the same way as the box on page 19. But this time, paint each side separately with its own color. Paint the top of the brick first, using the colors shown below. Then paint the light side and finally the dark side. The recess in the top of the brick was done last by adding shadow to its left side.

Now use newspaper. Page 22 shows a newspaper with a banana painted on it. The banana was drawn on the newspaper with a 3B pencil. Then the background was painted. Don't try to follow the pencil line too carefully. If you go over the line, it doesn't matter. The color will cover it.

Now, paint the banana. Use a No. 4 nylon brush and a mixture of cadmium yellow, raw sienna and white, with burnt umber for the spots. Use burnt umber and ultramarine blue for the blue background. Keep the paint thick rather than wet because newspaper is porous. Water will make the paper mushy. The dry paint will strengthen the paper because acrylic is actually a thin layer of plastic.

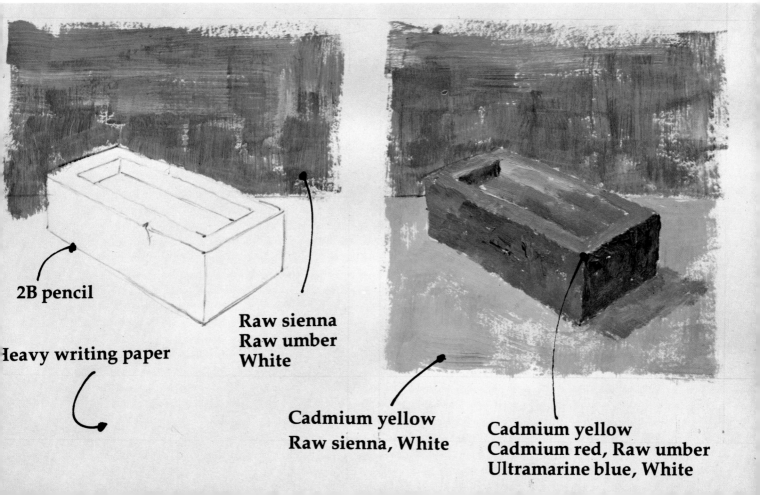

2B pencil

Heavy writing paper

**Raw sienna
Raw umber
White**

**Cadmium yellow
Raw sienna, White**

**Cadmium yellow
Cadmium red, Raw umber
Ultramarine blue, White**

Matche teams in melee

A STRUGGLE TO DRAW

LGO benefit
transfusion

being ... on in ennis ... way First ... s that ... wide ... eaker, other ... od in

TABLE TENNIS

Cook getting the other two for Mouchel.

In Division Two the ... Ae teams started well. T... D 7-3 with their A ... Mouchel B 6-4 with ... the latter match ex... ... John Hodkinson... ... on a comeback, ... John Stetfield.

Newsomerst... out of a goo... over Old W... led by ... served ... over the... Woking... did ... Cooper... while th... Theresa Watson, t...

CKETERS
NDOORS

... of the ... which ... onal ... t in ... rprise ... year's ... started ...

Esher were the vic... run, 66 to 65.

Woking and Horsell ... on the wrong side of BA... again by the odd run and ... an identical score, 66 to 65.

After a bad start, Avon... thrashed Westfield 108 to 55. Keith Bedford pulled them together with a fine knock of 46 after they had lost their first three wickets for 20 runs.

Byfleet beat Old Hamptonians 86 to 85 in another well contested game.

and Gordon Aplin all scored one each.

Newly promoted Post Office A carried on in Division Three where they left off last season with a 10-0 win over New Haw A, who had ex-Division One player Alan Hughes in their ranks.

In Division Four Post Office B were defeated 8-2 by Old Woking C. BAe D beat Byfleet LTC F 7-3. Dave Thomas winning a 1 three. However, BAe E went down 6-4 to Birdseye whose number one, Ian Hunt, won all his games.

Newcomers CUACO drew with Bowleys B, their top player, M Derbyshire, winning his three singles. In the same section BAe F won 9-1 over Mouchel D and Hersham B beat Airscrew D 8-2. Both Division Six results were 6-4 wins, New Haw B beat Broadoaks C and BAe G beat ... LTCH.

Division One: Nalro A 9, 77 ... 6-1, Byfleet LTC A 5, Mouchel A 5.
Division Two: BAe B 6, Mouchel B 4, BAe A 7, 77 D 3, Old Woking B 3, Premier A 7.
Division Three: Post Office A 10, New Haw A 0.
Division Four: Byfleet LTC F 3, BAe D 7, Old Woking C 8, Post Office B 2.
Division Five: Airscrew D 2, Hersham B 8, Mouchel D 1, BAe F 9, CUACO 5, Bowleys B ...
Division Six: New Haw B 6, Broadoaks C 4, BAe G 6, Byfleet LTC H 4.

BEXLEY 1, CHOBHAM 1
(Spartan League)

ALTHOUGH Chobham held the lead for most of the game, they were very lucky to get a point as Bexley posed a very real threat from start to finish. Certainly during the first half a goal to Bexley seemed inevitable as they won the majority of the high balls.

Their attacking moves called for many good saves from an improved Steve Osgood and goalmouth clearances by Mickey Elliott, Pat Folan and Phil Marlow.

Despite this good defence on Chobham's part, Bexley still had more than their share of shots just scraping the cross-bar. An early infringement by Bexley's goalkeeper saw Chobham awarded a free-kick which unfortunately did not pay off. Neither did they benefit from a chance made by Keith Lawrence when, after a late sprint down the right, his cross was not followed up.

After 25 minutes Norman Rudd got into his stride and ran the ball nicely past Bexley's defence to score for Chobham. Just before the interval Chobham put in a good attack but it was Bexley who at the half-time whistle had a dangerous looking move going, but this was ... ped by Elliott putting the ball out of play.

Despite appeals by Bexley for offside, Peter Hennessey later broke away but his first shot came off the goalkeeper and his second went just over the bar.

With 15 minutes left to play, a good shot by Bexley was headed clear by Elliott. Then to much amazement the referee awarded Bexley a penalty for alleged pushing by a Chobham player. From the spot Peter Raven made no mistake and Bexley were on equal terms.

The home team again came very close to scoring in the closing minutes. Chobham's last chance went to Elliott but his free-kick was superbly pushed over the bar by Bexley's substitute goalkeeper.

Nice surprise came after the game. The Bexley play... dismantled and stored away ... goal posts. It transpires that they also pay for the task of training.

Chobham: Osgood, Marlow, Folan, Elliott, McGonigle, Hennessey, Rudd, Webb, Langley, Lawrence, Finn. Subs: Ricto, Minnett.

PENAL ES

Early in the second half came proof of the new ... lone being adopted by Spartan League officials, when a ... of the referee by Bexley's goalkeeper resulted in his immediate dismissal from the game, and an indirect free-kick awarded to Chobham.

Home team in vain bid

RICHMOND VILLA 4, MONUMENT RANGERS 2

VILLA took an early lead when a ball almost on the byeline was ... passed across the ... In the second ... play was confined ... but ... got ... the game. But the home side scored twice more to end up 4-2 winners.

Monument Rangers: Chamberlain, Lee, Mama, Clarke, Evans Davies, Crooks, Mandeville. Subs: Hack, Meredith.

MERVYN W... ...
Lingus trophy ... the Woking Irish Association's first golf competition at Foxhills last week. The B. & I. trophy was won by Geoff. Endicote of West End. Above: F. O'Shea seems to have lost sight of the ball. Below Ted Phelps drives for home.

Re...serv...out

FRIMLEY GREEN RES. 1, SHEERWATER ...
(Surrey Intermediate Cup)

SHEERWATER travelled to Spartan Leaguers Frimley Green and were unlucky to come away empty handed.

The visitors dominated the first half and as early as the first minute a Dave Steel shot was cleared off the line by a defender.

After 20 minutes Frimley took the lead against the run of play, when a long throw-in was headed in by Hickman.

Sheerwater continued to attack and were unfortunate not to equalise before half-time.

After the interval Sheerwater continued to pressurise for the goal they deserved, but to ... Graham Tancock came close ... and ...

Cards loose grip

WOKING RESERVES 0, STAINES RESERVES 4

ONCE again injury prevented Manager John Martin fielding the older heads to steady his younger players in the step up to more senior football.

Staines presented one stronger side to visit ... but to spite of this the side acquitted ... during the ... the inj...

... Club v ... Legion ... A Nev ... Park ... and ... CC ...

Staines' third goal came as a proof of the ... lone being ... adopted by Spartan League officials, when a imprecation of the referee by Bexley's goalkeeper ...

a bad thigh injury. Woking were unlucky when, dying minutes of the the referee penalised ...

Flying sta... for ...

WOK... WES...

WOK...
flying ...
match g...
on two ...
fine ...
mat...

... second ... arrang... ... of the match from the Frimley keeper. Manager Tony Bristow made two substitutions which almost paid off when one of them, Dave Watts, broke through the defence and shot inches wide in the last minute.

Sheerwater Res.: Annas, Evans, Davis, George, Green, Ball... ... Steel, Watts, Tancock... ... Subs:...

Field still out of luck

MALDEN TOWN 1, WESTFIELD 0
(Home Counties League)

FIELD must be wondering what they must d... change their luck. Playing against an experie... Malden side, they completely outclassed them ... long periods of the match ... ball hitting the ... knee and sailing over ... crossbar.

Town started with a strong wind in their favour, but the dash and control of Channon, Stillwell, and Jones had their defence in a shambles.

But, completely against run of play, Malden sc... from a free-kick.

Field continued forw... looking for an equaliser, chances falling to Gary J... Jim Stillwell and Robson alas it was not Westfield's ...

Twice in 20 minutes a Malden defender scrambled the ball off the goal line.

Field's centre half had to come off because of a twisted ankle and Dave Robson took his place, with John Rose moving to defence.

Brian Paramore and Ian Barrow were doing well in Field's defence. Good interchanging space for Stillwell to get ... goal, but without ... Just before half-time a kick by Jones was cleared al Field had es to have seen ...

Westfield: Gould, Unw... Barrow, Paramore, Pat Legge, Channon; Still Jones, Rose, Buchan Robson D.

WESTFIELD RES. ... VIRGINIA WATER ...

THE Reserves continued run of seven games with defeat, with a brilliant ... the Intermediate Cup.

Field quickly settled into good constructive football chances falling to Dodd Collett.

In the 15th minute Jeffries hit a long pass to Brown who scored early.

Virginia Water fought to get back into the game found Daly, Styles and Ford in excellent form.

In the 30th minute Be... beat two defenders to sco... second goal. Then a minute ... the Field left-back, enis... ... at 2-1.

Just before half-time scored the best goal see Woking Park this season. ... started the move deep in ... half. The ball touched ... players before he hit a ... mendous 20yd. volley into ... Virginia Water net: 3-... ... cond cond ...

Westfield: Jeffries, Brown Daly, Styles, Rowbotham, ... Collett, Dodd P., Buchan Brown. Sub: Dodd A.

Replay will decide issue

BISLEY 3, HORSELL 1

IN extra time Bisley ... ahead. But on the turn ... Peter Eyles scored to ... Horsell a draw and a rep... the Surrey Junior Cup.

Horsell: King, Clark, organ, Posey, Eyles/Mun... ... att, Mercer, Harper, ... Pelham, Richards.

... of side the b... ... Pope scored for the h... ... the Social keeper too... ... wolley up field to c... ... who slotted the ba... ... Horsell home side... ered again be... Howell for... home side he se... ... Park, Tay... ... y, Simp... ... ga... ial ... Park, Tay... ... Simp...

Netball
...

Rugby
(Saturday, October 14)

A XV: Chobham v. Guildford and Godalming. Ex A, XV: Chobham v. Haslemere; B XV: Chobham v. Haslemere, BAe 1st XV v. Wimbledon if away; BAe 2nd XV v. Wi...d... f ? (home).

Woking takes command

... HAMBLE OLD BOYS 2

... at a Woking ... the domination ... ed in this game. ... against a good side ... a ... ther league.

Woking started well and the goals from Prushaw and Oliver were just rewards for their efforts. The game, however, was ...

Continuous pressure brought about a short corner, which resulted in a penalty flick when a solid stick tackle prevented the shot being made. This was coolly converted by Browse, one of several new young players in this year's first team.

A misdirected push in from a ...

Craig, Wren, Oliver, Prushaw, Corser, Browne.

... HAMBLE OB 11 5, WOKING 11 2

THE teams were well matched. The score could easily have been Hamble 8, Woking 8, but it was not to be, and Hamble ended up winners on the day.

Gaps in the Woking defence allowed the second of the two ...

... to Woking's first goal. A deceptive shot from Peirce glided past the goalkeeper when he appeared to have it covered.

Hamble failed to convert a penalty flick, the shot being saved by Wareham, but another led to the fourth goal.

A fifth soon followed with the defence very square. However, Woking were still able to reply, Burch scoring a fine goal with ...

xt Home Match

...LDERSHOT ... LPOOL UNITED

... October 14 Home... ...sion at Ground ... Adults £1 2p ... Division Four to 1... Juveniles 70p

... Geoff Parn... ... remembered for his ... work with North Farnbo... ... FC, his work with the ... Woking and the District Lea... ... and for his services to schoolboy ... football in the Farnborough ... area.

... It is hoped that the game will ... be well supported, as it is for a ... very good cause.

The Woking and District League would like to thank Woking FC for use of their facilities for a training session, and Barry Kimber, Woking FC's physiotherapist, who will ...

The banana at bottom left was painted on top of primer. The paper was primed with acrylic primer to counteract the absorbency of the newspaper. When it was dry, I drew the banana with a 3B pencil and painted it using the same paints as before.

The orange was painted directly on the newspaper without priming. I mixed cadmium red, cadmium yellow, burnt umber and white for the fruit, and bright green and burnt umber for the background. This time, try using the paint thick enough to create texture.

Next, use brown paper as a painting surface. I have chosen a pan for this subject. A pan requires that you draw a round object instead of a square one. The drawing problem here is the ellipse—the oval shape you see when you look at the pan. When you draw an ellipse, never give it pointed ends. The line must be continuous and smooth. An ellipse is a circle that gradually appears to flatten according to your eye level.

Instead of the clean, crisp edges of a box, you now have rounded forms to paint. The pan's shape requires you to mold and graduate the color to portray a curved surface. Molding of form can be accomplished by working paint from light to dark. Or start with the dark side and add lighter color as you move to the light edge of the pan. You may need to work on the pan more than once to practice painting round surfaces.

Now you'll need heavy white paper again. Select a book, preferably a solid-colored one, and sketch it on the white paper as shown on the next page. You are back to the shape of a box again, but this subject demands extra skill.

Begin painting as you did the boxes on page 19. When you begin to paint the pages, squint to see how dark the white pages are on the shadow side. You may be surprised to find how dark they are. Use a square nylon brush to paint the pages. Some of the brushstrokes should look like edges of pages.

Colored paper is the next painting surface. This exercise has the trickiest subject so far: a glass. Use one that is simple in shape. The secret lies in what you leave out, not what you put in. Paint the background thinly to let the drawing show through. Working from top to bottom, put a dark value on the shadow side of the glass. Draw the ellipse on top and bottom of the glass with a small sable brush.

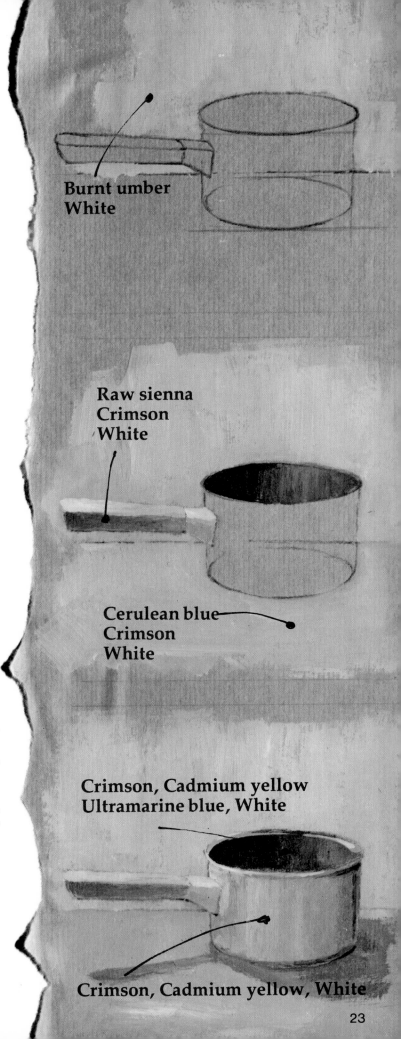

**Burnt umber
White**

**Raw sienna
Crimson
White**

**Cerulean blue
Crimson
White**

**Crimson, Cadmium yellow
Ultramarine blue, White**

Crimson, Cadmium yellow, White

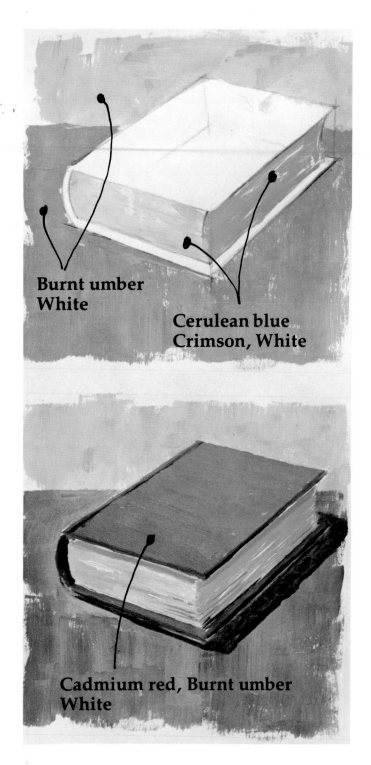

Burnt umber
White

Cerulean blue
Crimson, White

Cadmium red, Burnt umber
White

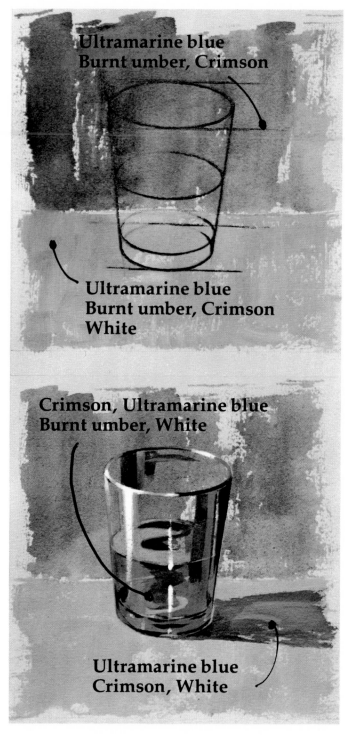

Ultramarine blue
Burnt umber, Crimson

Ultramarine blue
Burnt umber, Crimson
White

Crimson, Ultramarine blue
Burnt umber, White

Ultramarine blue
Crimson, White

A book and a drinking glass are good subjects for experimentation. Each presents particular problems. White pages aren't really white and water isn't really colorless.

Working again from top to bottom, put in highlights on the left.

Now use a canvas. I have sketched a simple landscape with a tree. This exercise may seem advanced, but it will add interest to the exercises you have done. Use the same methods you have used up to now. Avoid detail and try for shapes, colors and correct values.

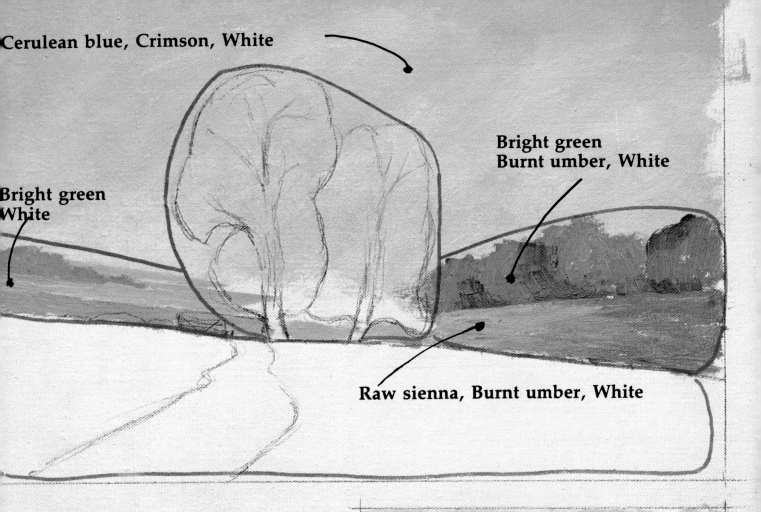

Cerulean blue, Crimson, White

Bright green White

Bright green Burnt umber, White

Raw sienna, Burnt umber, White

Draw the picture with an HB pencil. Then paint a clear, blue sky, using the colors shown. In the second stage—shown at right center—paint the middle distance when the sky is dry. Next, using broad brushstrokes, paint the large tree and foreground. For the lighter greens and the foreground, use fairly thick paint to add texture. This will help bring the foreground nearer and push the background farther away. Don't try to put detail in this picture. Details will come at a later stage.

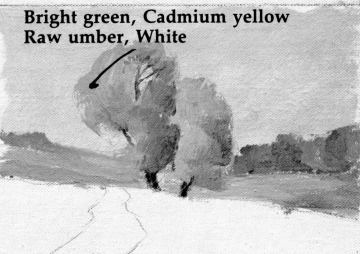

Bright green, Cadmium yellow Raw umber, White

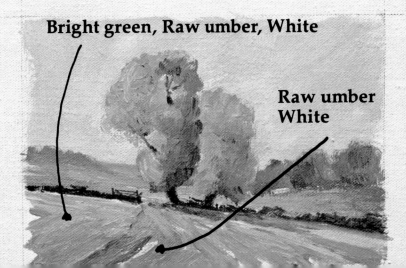

Bright green, Raw umber, White

Raw umber White

Basic Acrylic Techniques

If you have practiced the earlier exercises, you should be used to handling acrylic color and know the feel and texture of it. The previous lessons have shown you different techniques for using acrylic paint. For example, you may have found a way to paint a thin line with a thick brush. Don't think this is wrong. Generally, any way you achieve a desired result is fine. In this section, I will explain some of the techniques I use for acrylic painting.

In all the illustrations, I indicate the movement of brushstrokes with *black* arrows. The brush movement on the canvas—working from top to bottom or bottom to top—is marked with *outline* arrows. In the first illustration at left, the brush is being moved from left to right, top to bottom.

WET-ON-WET

This is the name given to the method of brushing watery paint into more watery paint already on a canvas. This technique helps blend colors or graduate them evenly from dark to light. On small areas, wet-on-wet painting can be done easily with acrylic color. But if a larger area is to be painted wet-on-wet, use acrylic gel retarder. This material will slow the drying process and allow time for wet-on-wet painting. Use one brush of gel retarder to one of paint. You'll learn from experience how much is required. Move the brush from side to side, blending colors together to get soft edges. In the wet-on-wet painting at bottom left, the strokes are being worked downward from the light of the cloud to the darker values.

THIN PAINT

Painting with thinned acrylics achieves a transparent look. This technique can be done at any time. If you paint thinly, it means the surface will show through your paint. The surface could be the clean canvas or areas of already painted color. Painting thinly is a technique of glazing. At left, thin acrylics are being used to paint the sky over the outlines of buildings. To achieve this effect, brush the color in more than usual—it will spread, thin out and become less opaque.

DRYBRUSH

This technique is used with most forms of painting, including acrylics, watercolor and oil. It is used to achieve a rough hit-and-miss effect, giving sparkle to the brushstroke. It can be applied to many subjects to portray certain appearances. One of the most natural applications of drybrush is water. Drybrush can portray ripples, sparkles, highlights and movement in water. The illustration at right shows water reflections and highlights. The drybrush adds sparkle and movement.

Load your brush with paint and brush most of the paint on the palette until only a little remains. Then drag the brush from left to right in straight, horizontal strokes across the water. The paint will hit and miss, leaving some of the background showing through. For some effects, you can work thick paint in a drybrush technique over the same area time and time again. This will give depth in that area of the painting. With acrylic color, this can be done quickly because of the fast drying time.

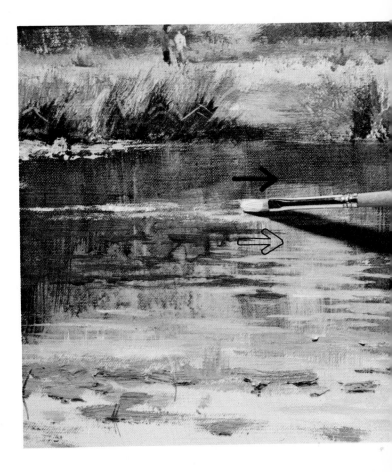

MISTY EFFECT

A misty effect in a landscape or seascape can create atmosphere. With acrylic colors, I can add mist to a painting at any time rather than working it in as the painting progresses. The paint dries quickly, so there is usually no waiting for this effect to be seen.

Dry the brush and add a small amount of paint. Rub the brush backward and forward on the palette until it is dry. This is the drybrush technique taken to the extreme. Scrub the area to be painted with the brush. The scrubbing will give the area a misty effect. Continue scrubbing and the misty areas will be more transparent as the brush uses up most of the paint. This is part of the effect.

Try not to have too much thick paint left by earlier brushstrokes on the surface where you intend to paint the mist effect.

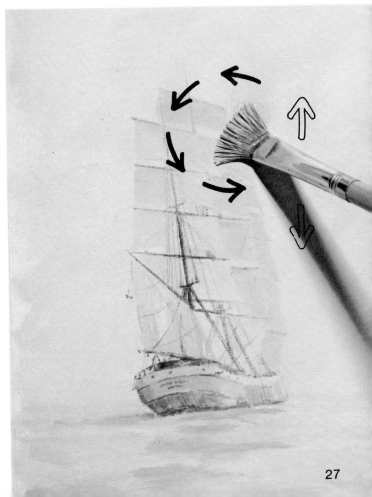

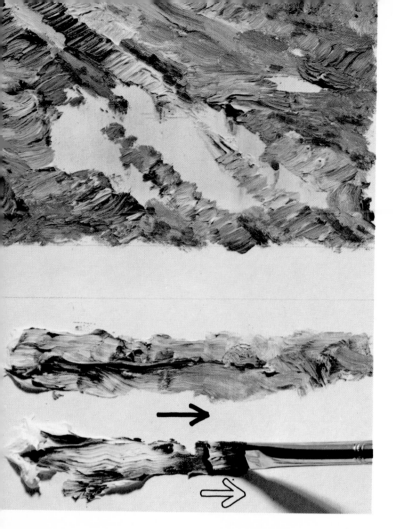

TEXTURE PASTE

Texture paste is an acrylic extender for building up impasto—or heavy—textures. The paste looks and feels like thick, white paint. It can be put thickly on any painting surface. When it sets, it is hard and can be painted over. It adheres well and is an ideal medium for collage work. I use texture paste for impasto foreground work, as shown in the brownish passages at left.

Put texture paste on your palette in the same manner as you would paint. Lift some off with your brush and apply two or three lumps on the painting. Then load your brush with paint, push the brush into the texture paste, press and pull away. The photograph of the brush at left illustrates this technique.

Acrylic is an excellent medium for impasto work. The ways of using texture paste on canvas are endless. Paint colors will be weaker when mixed with the white texture paste. If you want darker areas, paint those when the paste has dried.

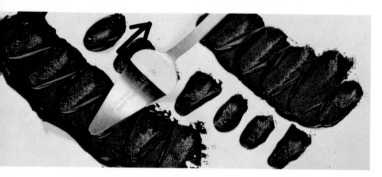

PALETTE KNIFE

Colors can be used undiluted with a palette knife to create many textures and forms. The paint retains its sharp edges and will not crack, even when put on thickly. The photographs at left and below show several shapes and forms that can be produced with different palette knives. At left, the small, pear-shaped knife is shown making a variety of shapes. The flexibility of the blade allows sensitive control. A medium, pear-shaped knife is used below left to mold orange forms and create surface-texture patterns. A narrow, trowel-shaped knife is used below right to cover an area with green paint. Always clean painting knives after use.

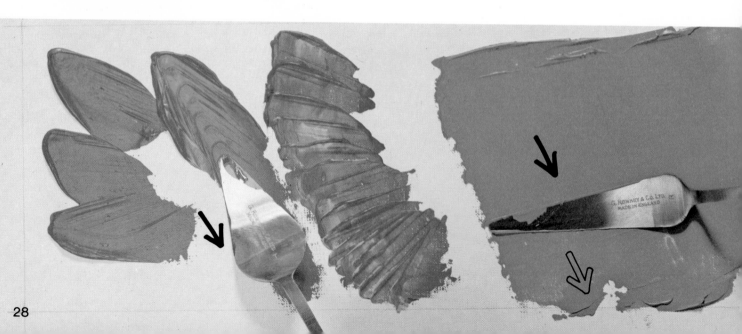

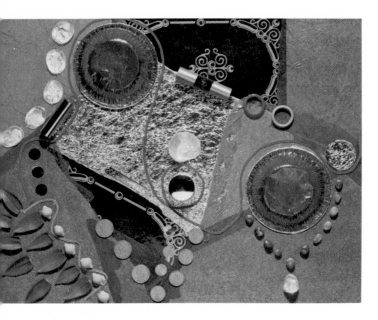

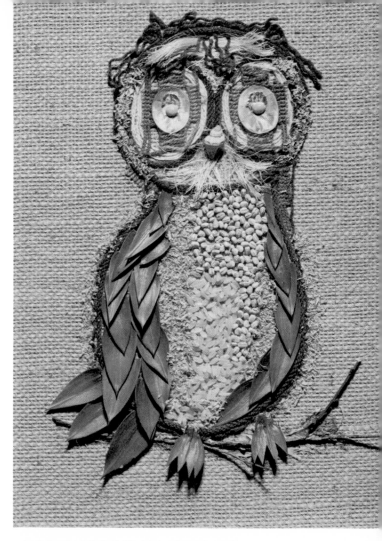

COLLAGE

The adhesive nature of acrylic paint makes it ideal for collage. The color can be used as both paint and adhesive. There are two transparent, colorless acrylic mediums available that can be used for gluing. One of them dries to a flat mat finish, the other glossy. Don't overload paint and mediums with materials, such as sand or marble dust. Overloading can cause cracking in thick areas. Cracks rarely occur, but if they do, fill them with more medium after a few hours of drying.

Texture paste can be used in collage. It is an ideal, thick, workable glue. It will hold anything in position, from a piece of paper to a lump of wood or plastic. The paste can be mixed with color or it can be painted when dry. In the photograph above—part of a finished collage work—texture paste was applied to the board first. Heavy materials were then pressed in and left to dry.

The owl above right is an example of what you can create with acrylic colors and mediums. The owl was designed and produced by my wife, using fabric as a support on hardboard. String, dried seed pods, wool, dried parsley, barley, rice, monkey-tree leaves, lentils, shells, twigs and tinfoil were also used.

Other materials that can be used for collage are plastic, metal, glass, all kinds of paper, cardboard, cellophane, feathers, colored foil and cork. You can also use wood, from tree branches to sawdust, sequins, string, textiles and dried leaves. If collage materials are covered with medium, they will be protected and sealed to the surface.

HARD-EDGE PAINTING

Acrylics have a high degree of opacity and can be brushed out smoothly to give flat, level areas of color. These properties are ideal for many abstract techniques. Hard-edge painting is a technique that involves painting one flat color against another with crisp, hard edges. Masking tape was used to achieve razor-edge sharpness between the colors shown below. Be sure to press the edges of the tape down firmly to prevent paint seepage.

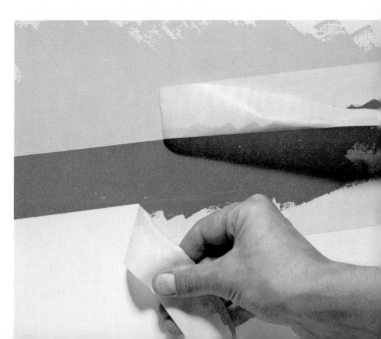

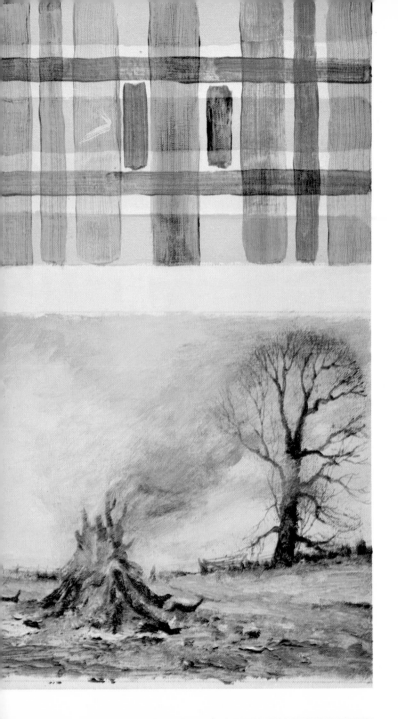

GLAZING

Acrylic colors produce rich, transparent glazes when mixed with a glaze medium. The more glaze medium you add to paint, the more transparent the glaze will be. A succession of thin glazes will produce soft color gradations and the effect of color fusion.

Three primary colors were used in the illustration above left. The initial yellow was overpainted with red and then with blue. This created secondary color effects where the primaries cross each other. In this illustration, a mixture of one part color to 10 parts glaze medium was used.

In the bonfire illustration, a glaze was applied to a conventional painting to achieve the smoke effect. Use the brush to achieve the same misty effect as described on page 27. But this time, add glaze medium. The medium allows paint to move more easily on the canvas. It also ensures that the paint is transparent. The glazed part of the painting will look glossy, while the rest will be mat. When you varnish a painting, the difference will disappear. The whole picture will be glossy or mat, depending on which varnish you use.

STAINING

Acrylics can be diluted with water and painted on unprimed canvas to get an even, mat surface of color. A water-tension breaker can be added. This helps speed flow of paint on canvas when large areas are painted. The tension-breaker also helps when the painting surface is porous as in unprimed canvas. Water-tension breaker slightly dilutes color, but retains maximum color intensity. This technique gives the appearance of a *stained* canvas, as shown at left, rather than a painted one.

MURALS

Acrylic colors are especially suitable for mural painting. Acrylics can be applied directly to plaster, masonry or canvas without prior preparation of the surface. But it is preferable to prime the surface with an acrylic primer, depending on the quality of plaster or cement. At right is a mural that my 18-year-old daughter painted on her bedroom wall.

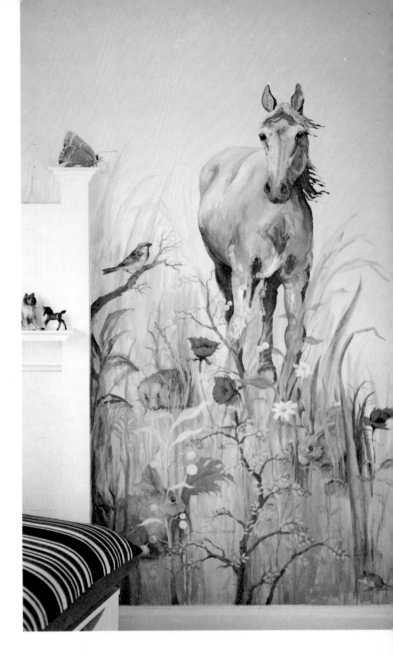

PRIMING

Priming is a method of sealing absorbent surfaces before applying paint. Acrylic primer should be used. Use a small, household paintbrush to apply primer, as shown below right. Avoid leaving stroke marks on the surface. Brush them out smooth. Wash your brush after use. Paper surfaces should not be primed.

Only the *basic* techniques have been discussed here. You will discover many other techniques that are useful to you. Don't be afraid to use what you learn if it helps your painting. If you stood on your head to paint and the result was disastrous, people would laugh at you. But if the result was good, they would marvel at you. Never worry *how* you paint if the result is pleasing.

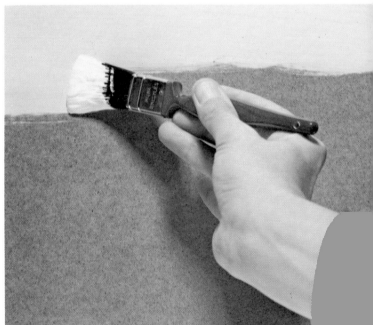

Advanced Work

By now, you will either want to proceed to the next exercises or continue practicing some of the earlier ones. Remember, don't run if you can't walk!

On the following pages, seven subjects are presented in stages for you to follow and copy. I explain how the work was done step by step so you can see the painting as it develops.

It is important for you to know the size of the *finished* painting—not the reproduction—so you can understand the relative *scale* of the painting. I painted all the exercise pictures on a 20x16'' canvas primed with acrylic primer. The close-up illustrations for each exercise are reproduced the same size as I painted them. You can see the actual brush-strokes and details.

Finally, I have illustrated the method used for a particular part of the painting so you can study it more closely.

A common question about painting concerns the use of photographs for reference. I believe that if the old Masters had had access to cameras, many would have used photographs to "freeze" a water-fall to study its form. The same would apply to a wave, a sunset and so on. We often look at still pictures of moving objects, so we take these things for granted. It wasn't until the advent of the camera that galloping horses' legs could be studied in a still view.

Cameras can also be used if you are interested in small details. If you begin to paint a complicated boat scene and some of the boats leave before you finish, then you can't paint the scene—let alone put in detail. But if you take photographs of the scene, you will always have a reference. A painting can be started outside without having to note all the details. You can concentrate on the picture as a whole, getting the feel of the atmosphere. Then you can put in details later at home, referring to the photographs.

These are the reasons why I believe cameras would have been used by the Masters. Some critics still frown on the use of photographs as painting references. I believe photographs are excellent examples of modern equipment, but don't let them become a crutch or an excuse. Let Nature be your primary guide.

Can acrylic colors be painted over oils? The answer is no, but the reverse is possible. You can paint oil over acrylic once the acrylic is dry.

When mixing acrylics, don't interchange different brands. Brand mixing is not advisable because different brands contain varying qualities and types of resin. Some resins are incompatible with one another. Mixing them can cause your picture to stay tacky.

The following exercises are painted in my own style. The way I painted is the way I work. I haven't altered my style for the book. But remember, we all have a creative style of our own that will emerge naturally. Once you have learned to use acrylics, let your own style develop.

The colors shown on the first page of each exercise are the choice of mixed colors used in that exercise.

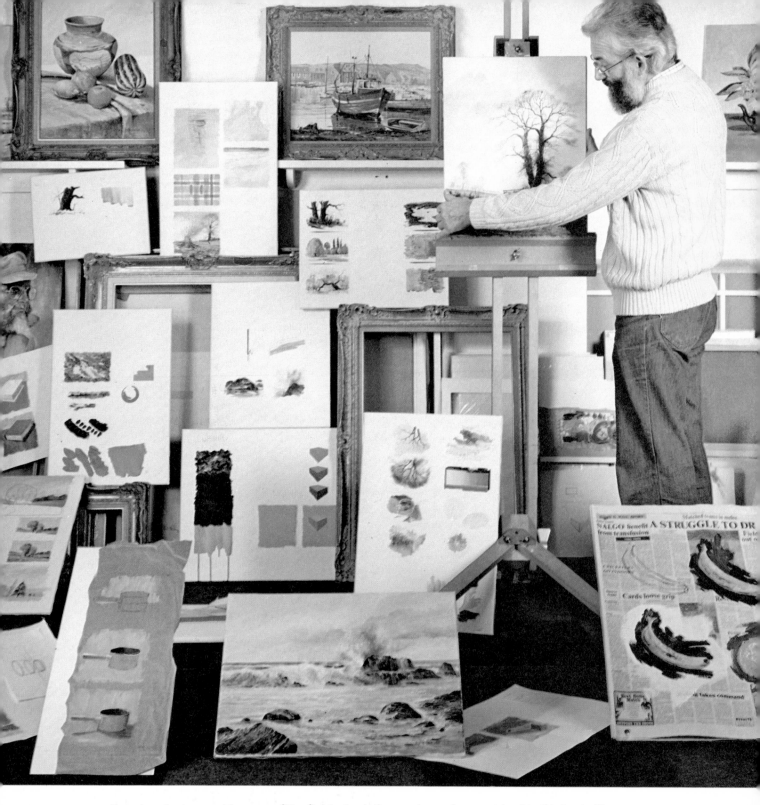

Crawshaw is shown with many of the finished paintings and exercises contained in this book. The author uses acrylics in a variety of techniques—including the thin, watery method of traditional transparent watercolors. He recommends using newsprint or heavy writing paper for practice exercises.

Painting A Still Life

For the first exercise, I purposely chose a still-life subject. You started with a brick in the first lesson on painting simple objects. A brick is easy to find and can be painted under conditions you control.

This is the beauty of still life. You control the lighting, size, shape and color of the subject. You can keep painting the same inanimate objects for years. Here are some important notes on still-life painting before you begin: Don't be too ambitious at the start. Set up a few simple objects on a contrasting background. The best light source is an adjustable lamp, which can be directed at the subject for maximum light and shade. Squint and you will see strongly contrasting darks and lights in the subject.

When you set up a still-life subject, make sure you won't need the objects for a while.

First Stage—Light source is coming from left and above. Light direction isn't obvious in the first illustration because I haven't drawn shadows. To begin, draw the line that divides the background from the flat table. Draw the vase, the line of the cloth, the squash, onion, lemon and orange. Mix raw sienna, crimson, ultramarine blue and plenty of white to paint the background, using a No. 12 nylon brush. Use the same colors for the table, but add more white. This area is directly lighted from the light source. Paint thinly over the drawing so you do not lose the lighting effect. In this exercise and others to follow, the first color is the main one. Mix other colors—in smaller amounts—with this base color. White is last, unless it is the main color.

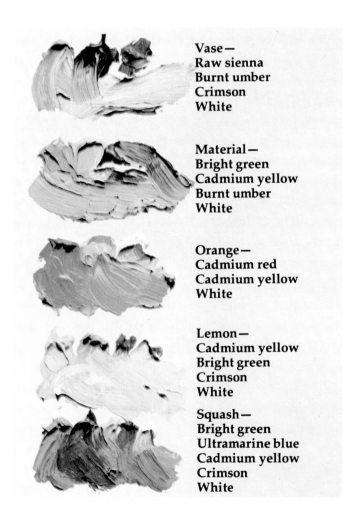

Vase—
Raw sienna
Burnt umber
Crimson
White

Material—
Bright green
Cadmium yellow
Burnt umber
White

Orange—
Cadmium red
Cadmium yellow
White

Lemon—
Cadmium yellow
Bright green
Crimson
White

Squash—
Bright green
Ultramarine blue
Cadmium yellow
Crimson
White

Second Stage—For the vase, mix raw sienna, burnt umber, crimson and white. Study the delicate values, highlights and shadows carefully. Use a No. 4 nylon brush for the rim and inside. On the inside of the neck, paint from the light side to the dark side. Add blue shadow while the paint is still wet—use a little ultramarine blue to darken the shadow. With a No. 8 nylon brush, paint the vase in a downward direction. Let the brush follow the elliptical shape. This will give the vase a natural, handmade look as the brushstrokes show the vase's contour. Paint the vase as though the dark brown pattern didn't exist. Then paint the dark pattern over the vase with a No. 4 nylon brush, using burnt umber mixed with a little white. Mix bright green, cadmium yellow, burnt umber, ultramarine blue, crimson and white for the cloth. Five colors plus white may seem like a lot for painting one color, but the basic color is green made from bright green, cadmium yellow and burnt umber. Other colors are added to help give it light and shade. They stop it from looking flat and dull. Start painting the cloth from the left of the vase and work downward. Add dark and light paint as you paint the folds and shadows. Use a drybrush technique to create texture in the material. Next, add shadows to the vase and striped squash. Use a No. 4 nylon brush with ultramarine blue, crimson, cadmium yellow and white. Note how the shadow is lighter toward the back.

First stage

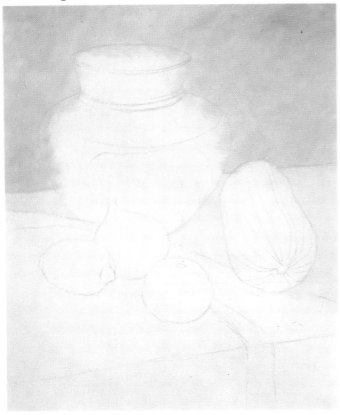

Second stage

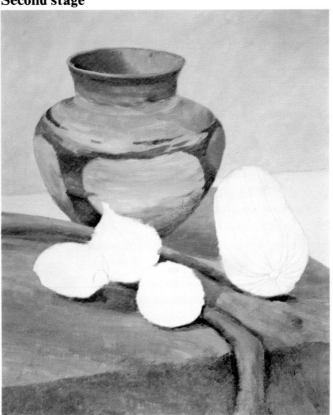

Third Stage—Mix bright green, cadmium yellow, crimson and white with a No. 8 nylon brush. Paint the light green of the squash, letting pencil lines show through. Now paint the onion. Mix cadmium yellow, crimson and white. With a No. 4 nylon brush, start at the top of the onion and let the brush-strokes form the veins of the skin. The darker area is a piece of skin peeling off. Add a little ultramarine blue to the preceding mixture to paint the peeling part. For the lemon, use the same brush. Mix cadmium yellow, bright green, crimson and white. Start with the highlight near the top left and work downward into the shadow areas. Paint the ends of the lemon carefully. Add dark accents to show their shape. Note the reflected light on the bottom where it meets the shadow. Paint the orange in the same way as the lemon. Use the same brush after washing it out. Mix cadmium red, cadmium yellow, a little crimson and white. Paint the reflected light on the bottom as you did on the lemon.

Final Stage—Begin with the squash, using a No. 4 nylon brush. Mix bright green, ultramarine blue, cadmium yellow, crimson and a little white. Paint the dark stripes. Let the brush miss the light. This creates the speckled, light shapes. Use ultramarine blue, crimson and bright green to paint a transparent wash over the squash. Using the same color, paint

Third stage

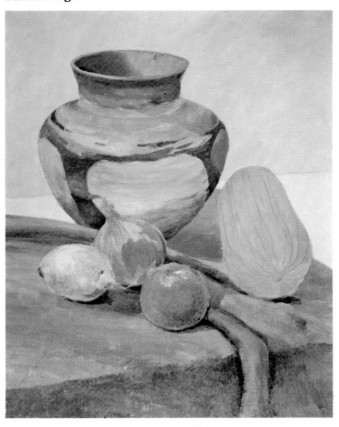

35

the right shadow side and front of the squash. The squash then will have form, making its shape recede into the background. Paint a transparent wash on the onion with your No. 5 sable brush to give the skin a transparent look. With a small sable brush, paint some veins. Next, darken the shadows on the cloth with your No. 4 nylon brush. Use ultramarine blue, crimson and bright green. Next, mix bright green, cadmium yellow and white and paint light areas freely with a No. 8 nylon brush. With a No. 2 nylon brush and the colors used for the lemon, stipple highlights and shadows on the lemon. Finish with a small sable brush. Use the same treatment for the orange. Darken the shadows on the vase. Use the paint thinly. Also, darken the shadow cast by the vase and squash. Draw the vase's bull design in pencil and paint it with a No. 1 sable brush. First, draw a dark line. On the highlight edge, paint a transparent yellow-white, broken line. On the opposite edge, paint a middle-value line. These lines will give the illusion of an engraved contour. Finally, study the work and add more dark or light accents where needed. As you paint the still life, remember to squint to see light and dark shapes in the scene.

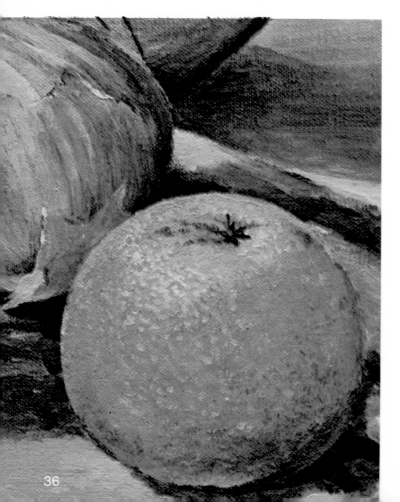

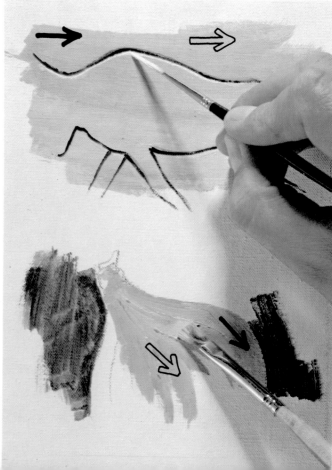

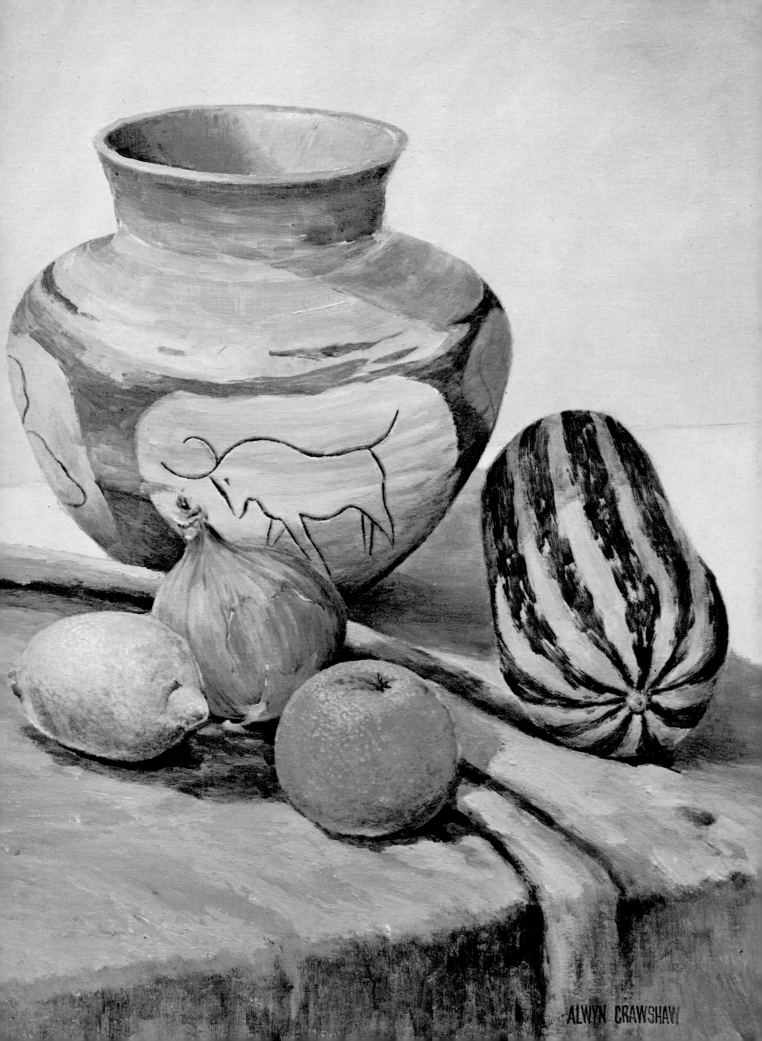

ALWYN CRAWSHAW

Painting Flowers

This is another exercise over which you can have considerable control. The main point to remember is that flowers change and eventually die. Any arrangement you prepare must last through your painting time. If you don't finish in time, change the flowers for fresh ones. Your painting skills should have progressed enough for you to improvise. It is an *impression* you are painting, not a *specific* flower.

A vase of different blooms, exciting shapes and colors can be inspiring. The subject can also be overpowering for a beginner and lead to disappointment. Study one flower at a time. See how its petals are formed and how it grows from the stem. Study the leaves. Put one flower against a plain, contrasting background to give it a clear, undisturbed shape. When you have studied one flower, put some in a vase and begin to paint. You may find it helpful to use other colors in addition to the ones on your palette. Pigmentation of flowers is unlimited. I have chosen flowers for this exercise that can be painted with the normal range of colors.

First Stage—The source and angle of light are the same as for the still life. Draw the line between background and tabletop first, then the teapot and finally the flowers and leaves. Mix raw sienna, cadmium yellow, crimson and white for the background. Paint thinly where you want the drawing to show through.

Second Stage—For the leaves, mix dark, medium and light green on the palette, using bright green, ultramarine blue, cadmium yellow and a little white for medium. Add more white for light. Add crimson and more ultramarine blue for dark. Paint the leaves with a No. 4 nylon brush, wet-on-wet. Work the brush into the center, then down each side. Follow the direction of the veins. With a mixture of cadmium yellow, crimson and a little white, paint the orange flowers with a No. 4 nylon brush. Start at the center and work the brush up and down to form petals. Go around the center and spread out to the edges of the flower. Continue in this way with the yellow flowers, using cadmium yellow, raw umber, a little crimson and white.

Third Stage—Now paint the tabletop. I have purposely used a non-shining surface, so you have to contend only with shadows and not reflections. Mix raw umber, crimson, raw sienna and white. Use a No. 12 nylon brush to paint from the top of the table downward to the bottom of the canvas. Don't try to paint *up to* the teapot with your No. 12 brush. Let the brush go *over* the pencil lines—the excess will be covered when you paint the pot. Start on the teapot using a No. 8 nylon brush. Mix burnt umber, crimson, ultramarine blue and a little white. Start on the teapot. Keep your brush flat as you move it down the pot. Curve the direction of the stroke to match the pot's shape. Work in the lighter areas as you paint. Add orange and yellow for the flower reflections. The shadows on the background are the next area to paint. Use your No. 4 nylon brush. Mix raw umber, crimson, cadmium yellow and white. The brushstrokes should follow the direction of the

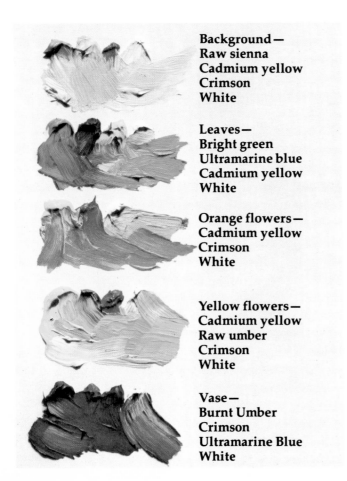

Background—
Raw sienna
Cadmium yellow
Crimson
White

Leaves—
Bright green
Ultramarine blue
Cadmium yellow
White

Orange flowers—
Cadmium yellow
Crimson
White

Yellow flowers—
Cadmium yellow
Raw umber
Crimson
White

Vase—
Burnt Umber
Crimson
Ultramarine Blue
White

First stage

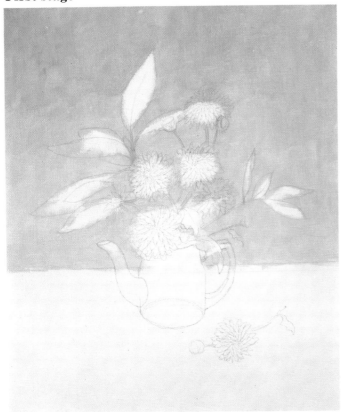

Second stage

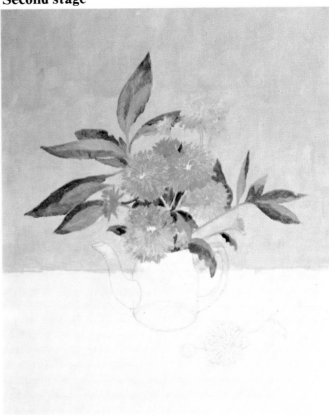

Third stage

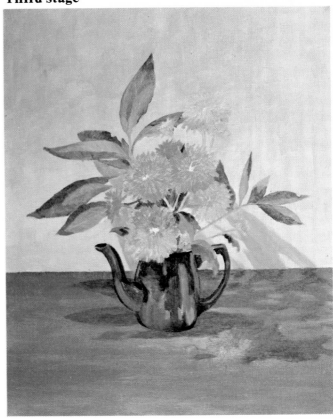

cast shadow. Now paint the tabletop shadows. Change to a No. 8 nylon brush. Mix raw umber, ultramarine blue, crimson and white. Keep your brushstrokes horizontal to make the shadows look flat. Be careful when changing planes from table shadows to background shadows. There are two definite planes—the perpendicular background and the horizontal table. Where the shadows have been painted over the teapot, use a No. 5 sable brush to paint the edge on the teapot. I did this on the bottom left edge of the spout.

Final Stage—Start by working more on the flowers. The aim is to achieve the appearance of hundreds of petals while actually painting only a few. Remember the importance of light against dark. Look at the top flower on the right. The dark shadow on the leaf emphasizes the shape of the light flower. The bright petals against the dark petals beneath stress the bottom edge formation. The same flower has lost some of its contour against the background at the top and on the right. This was done purposely to give depth to the flower. Too many sharp accents would cancel themselves out. No accents at all would result in a flat, dull picture. Knowing what to put in or leave out, especially when painting flowers,

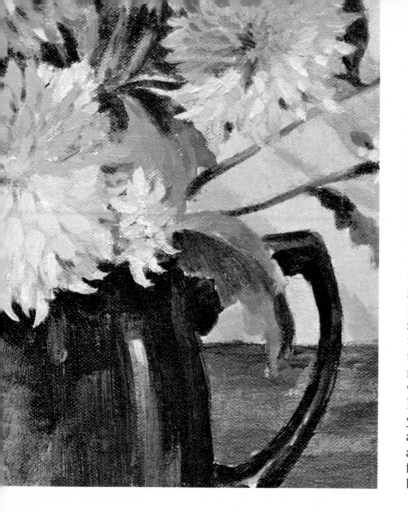

comes from observation and practice. You have already painted the light and dark areas. Now, use a No. 5 sable brush. Mix cadmium yellow, crimson and white. Add the light areas of the yellow blooms. Follow the shapes you painted in the second stage, but be more careful and precise with the petals. Work from the center outward. Press the brush down, pull it toward you and slowly lift it off. Practice on scrap paper. Make some petal shapes against the teapot—light against dark. Do the same exercise with the orange flowers. Finish the flowers with a sable brush by adding dark accents to help form petal shapes. Add some extra highlights. Darken some of the leaves to give them form. Paint over the stems in the middle to give them value, enabling them to recede. Paint the fallen flower on the table now—light petals against dark. Glaze the teapot with a blend of burnt umber and crimson, using a No. 5 sable brush. When the glaze is dry, repaint the yellow reflection and the highlights. Add some dark accents. When you have finished, put the painting away for 24 hours or so, then come back to it with a fresh eye. You will see things you had not noticed before. Correct these problems and you are finished.

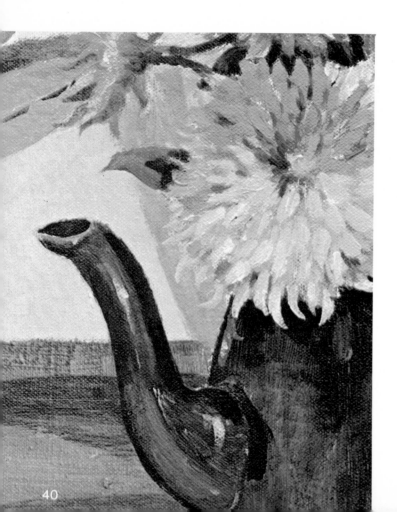

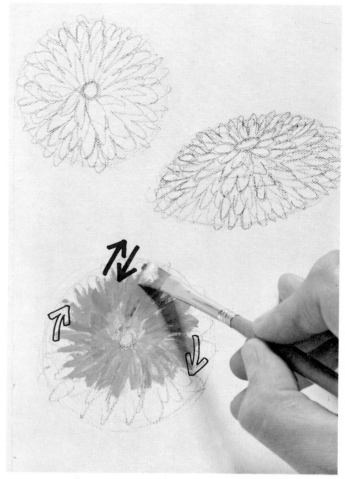

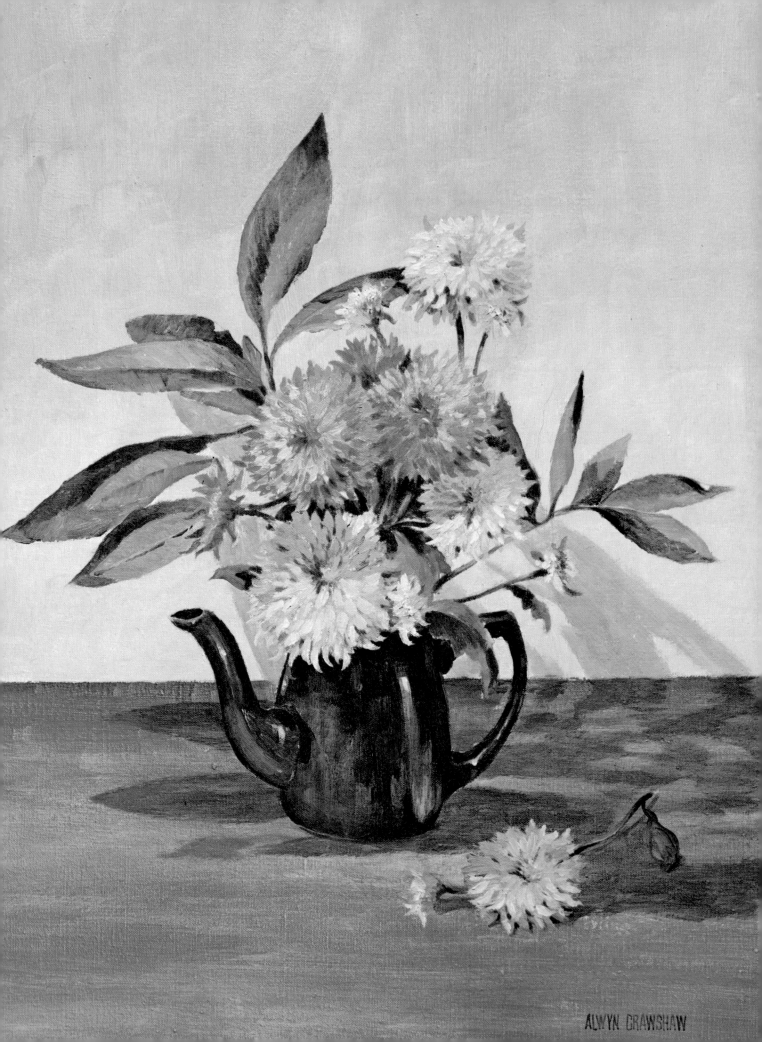

ALWYN CRAWSHAW

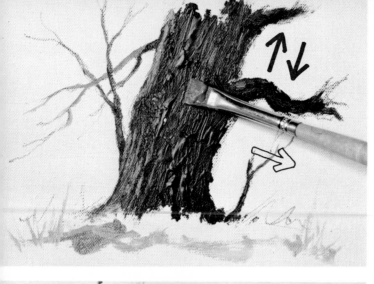

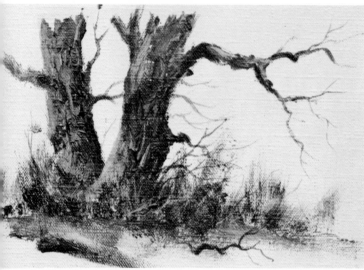

Notes On Trees

For the landscape artist, the tree is Nature's most valuable gift to assist with picture composition. One lone tree can make a picture, or several trees can be used to break up the horizon line. They can be positioned to stop the eye going forward or to lead the eye into the picture. Next time you go to sketch, pick out a good tree—one that shows the characteristics of its species—and draw it. Don't sketch it. Make a careful study, drawing all the branches you can see.

The best time to do this is when the tree has lost its leaves. You can see the whole shape. By drawing carefully and observing the tree, you'll learn the growth pattern. This will help when you draw trees in full leaf. In the summer, look carefully at a tree to see how many large and small branches are showing. You may be surprised how many can be seen against the foliage. In a painting, these branches against leaves help give a tree depth and interest.

Start by drawing one type of tree. Really study it. Then when you paint from memory or imagination, you will always have a tree you can paint. It is better to perfect one species than to attempt three or four different trees and find that none look like anything on earth! You can portray the look of bark on a tree trunk by using thick acrylic colors. Use these only on foreground trees, because texture makes the trees appear closer. You don't want the distant trees appearing to be in the front of the painting!

In the top painting at left, you can see how texture is achieved. Use plenty of paint, working the brush up and down the tree—mostly up. This action will form the texture. There is sometimes a problem with making trees appear to grow out of the ground. Unless the tree is on a lawn in a park, it will usually have growth of some kind at its base. The second sketch from the top at left illustrates this point. The natural cover makes the tree trunk appear to grow out of the ground without showing the actual base. When you paint trees in the middle distance, don't neglect them just because they are a long way off. Observe them carefully and pick out the different shapes, as shown in the third sketch from top.

A tree can form the foundation of a painting's composition, as shown at bottom. I saw this fallen willow with a church in the background. It was a different view of the church tower created overnight by Nature. When you paint trees, paint them with *feeling*—they are alive, not just planks of wood.

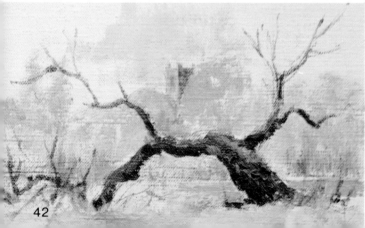

Notes On Water

The color of water is normally a reflection of the sky and immediate surroundings. In very clear, still water, the reflection of a building can be mirrorlike. In that case, the water is painted as a building upside-down. The reflection appears to go *down* into the water, not *across* the surface. Only movement of the water shows as horizontal lines. Movement breaks up reflected images. Light on moving water is also seen horizontally.

The first principle for painting water is to make all movement lines or shapes *horizontal* on the canvas. If the lines aren't horizontal, the river or lake will appear to slope. Use the paint like watercolor when painting water with acrylics. The paint should have a very watery consistency. Move a flat nylon brush from top to bottom, then left to right, as in the top illustration at right. The color of the first wash depends on the reflections in the water. It may be necessary to paint more than one wash to get the depth of value required. Let each wash dry before applying the next. Using thin paint is a simple way to create the illusion of water. In the second sketch from the top, the water was painted in a light value. Then dark color was painted around the water to represent earth or a muddy path.

On the left edge, dark shadows were painted with a small sable brush. The third sketch from the top was created in a similar way, except the water is darker and the path lighter. In the boat exercise beginning on page 56, the water of the harbor is painted this way. When you have movement on water, such as ripples or small waves, paint the water as in the sketch at top. This method is used to paint large lakes or small puddles. Then paint the different values over the water with a small brush. Let the brushstrokes create the effect of movement. You may find much of your original wash is covered up. But these washes create the illusion of water, as shown in the bottom sketch.

Occasionally, you may paint water that has no distinct reflections. If the water needs a reflection to make it look "real," then put one in. Perhaps a post, a fence or a fallen branch will do. A reflection immediately gives the illusion of water.

Painting A Landscape

If you lack confidence in painting landscapes, take a sketchbook and go find a spot behind a tree. Make a quick drawing of a scene you would like to paint. Note the main colors in pencil. Then paint it at home. You will become accustomed to working outside without looking like a portable studio.

Take your paints outside with you as your confidence grows. Most of the people who stop to watch will admire you and your work. Sketching in pencil is good for the person who can't often get outside. Don't always paint when you go out. Make pencil sketches, perhaps as many as six in a day. Then use the information from the sketches to plan paintings.

Don't neglect Nature as you progress with landscape painting. Even in town, the sky can always be seen and painted from a window. But sketch and paint the countryside as much as possible from life. Always have a sketchbook with you. It is helpful even if you have only 10 minutes to sketch a scene and draw a few lines. The landscape chosen for this exercise covers two important aspects of Nature: sky and ground.

First Stage—Draw the horizon line. Then draw the two sloping fields to the left and right of the road. Next, draw the road, the two main trees and the trees in the middle distance on the left. For the sky, mix ultramarine blue with crimson, raw umber and white. Start at the top and work down the canvas, using a No. 12 nylon brush. With the same brush—not washed out—darken the color. Add a little raw sienna to give it more body and paint the darker clouds. Now, wash the brush. Mix cadmium yellow, crimson and white. Paint the lighter cloud area down to the horizon. As you near the horizon, add more crimson. Add a little more ultramarine blue to the right of the trees. Gel retarder will help with the wet-on-wet technique in this stage.

Second Stage—Paint the light-colored field in the middle distance, using a No. 2 nylon brush. Mix raw sienna with white and a little ultramarine blue. Drag the same brush in a drybrush technique along the top edge of the field to form the distant hedge. Use a No. 4 nylon brush to mix ultramarine blue, crimson, cadmium yellow and a little white. Apply the drybrush technique again to paint the trees on the left and right of the road. Don't put in details yet. Mix raw umber, cadmium yellow, bright green and a little white for the trunk of the double-trunked tree. The left trunk is partially lighted halfway up by the sun. Start with plenty of paint and a No. 4 nylon brush. Work up the trunk, painting progressively smaller branches until the brush is too big. Then change to a No. 5 sable brush and continue painting the branches. Always work up and out when painting branches, in the direction they grow. Now, paint the right tree, using raw umber, bright green, crimson and ultramarine blue. When painting trees, the background will show through in places. This is a desired effect. If you properly work your brush up

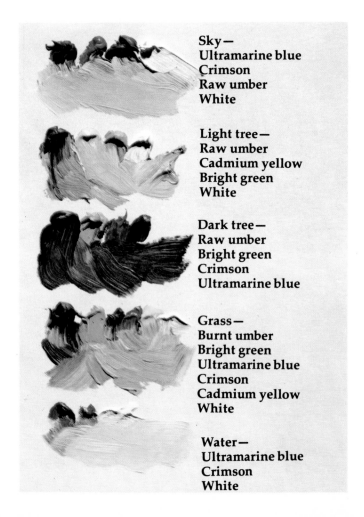

Sky—
Ultramarine blue
Crimson
Raw umber
White

Light tree—
Raw umber
Cadmium yellow
Bright green
White

Dark tree—
Raw umber
Bright green
Crimson
Ultramarine blue

Grass—
Burnt umber
Bright green
Ultramarine blue
Crimson
Cadmium yellow
White

Water—
Ultramarine blue
Crimson
White

First stage

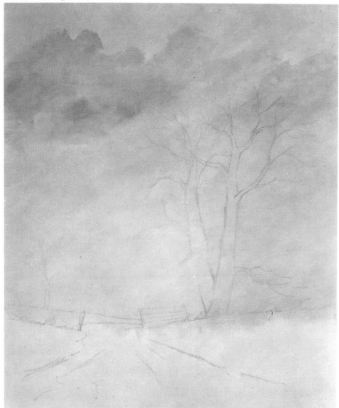

Second stage

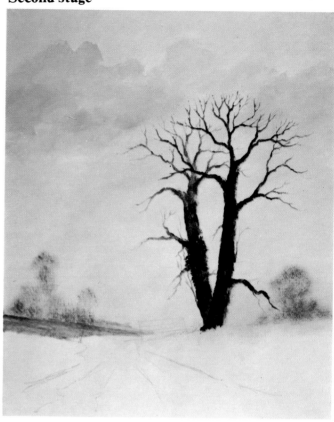

Third stage

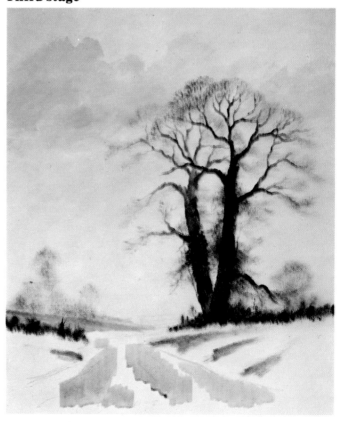

and down the trunk, you can create the impression of bark. Don't worry now about light and shade. These effects will be added later. Use plenty of paint on the tree trunks to create gnarls, lumps and bumps. Use thick paint only on close-up trees, not on distant ones. The loose, soft drybrush technique is all that is required to give the background trees a distant look.

Third Stage—Begin with a well-dried No. 8 nylon brush. Paint the feathery branches on the left tree. Follow the growth of the branches with your drybrush strokes. Use cadmium yellow, crimson and raw umber. For the darker tree, mix ultramarine blue, crimson and burnt umber. Add the tall grass, using the same drybrush technique. Push the brush upward in the direction of growth. Add cadmium yellow to the colors used for the tree on the right. Now, mix ultramarine, crimson with a little raw umber and white in a watery wash. Use a No. 8 nylon brush to paint the road's water area. Use downward strokes. Finish this stage by using a No. 4 nylon brush and adding some brushstrokes on the foreground field to show its contours. Use raw umber and bright green.

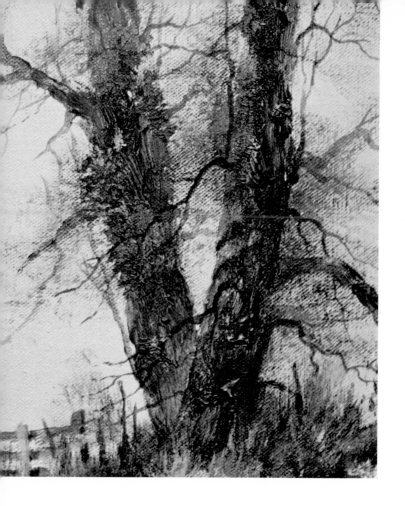

Final Stage—Start under the hedge on the right and paint the field. Use texture paste with bright green, burnt umber, crimson, cadmium yellow and ultramarine blue. Work your No. 4 nylon brush in the direction of the field's contours. Flick the brush up into the hedge occasionally to break up straight lines. Paint the road next, using the same size brush. Blend raw sienna, raw umber, burnt umber, crimson, ultramarine blue and white. Load the brush with paint and texture paste, then drag it down the edge of the puddle. The texture paste and paint will form a natural-looking edge of the water. While this area is drying, use a No. 2 sable brush to finish painting the smallest branches of the large trees. Start with the left tree. With a drybrush technique, paint highlights on the trunk and branches. Use a No. 5 sable brush and watery paint to apply the shadows. With the same brush, mix ultramarine blue, crimson and white. Using a drybrush technique, paint the main trunk and branches of the middle-distance tree on the left. Paint the gate and fence, using a sable brush with raw umber, bright green and white. With a No. 5 sable brush, add the shadows at the bottom of the road. Use watery ultramarine blue and crimson for a transparent effect. Add accents where needed.

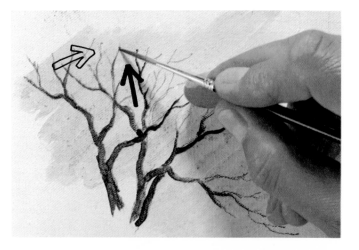

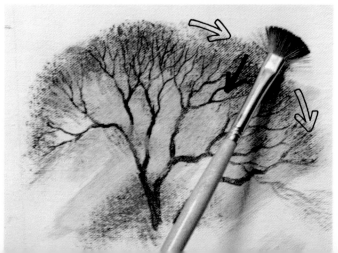

ALWYN CRAWSHAW

Painting A Seascape

The sea has always fascinated artists. Many landscape artists also paint the sea. Two of the finest landscape artists—John Constable and J.M.W. Turner—couldn't resist the call of the sea. I think the sea is fascinating because it seems endless. It is vast and restless, never still. It has extremes of mood ranging from blissful and romantic to terrifying. Like the sky, the sea changes color all the time.

As a painter, you must observe the sea's characteristics from life. Sit on the beach and watch waves coming in and breaking on the shore. Learn how a wave forms and how it breaks. Try sketching waves with a 3B pencil, concentrating on the overall form. You can't draw the same wave—it's only there for seconds—but more waves will follow. Try to retain the image. Then try painting from life. Remember, the horizon line must always be horizontal or the sea will appear to slope. If necessary, lightly draw the horizon line with a ruler. The sky must be similar to the sea in color and value. You can usually use the same colors for both. Add cliffs, beaches, rocks and boats to give more interest in composition and color to a seascape. Cliffs and headlands give distance and perspective. Beaches and rocks set a scene to paint crashing waves, with spray and foam flying everywhere. I have included rocks in this exercise because they are a good subject for acrylics.

First Stage—Draw the horizon line with an HB pencil. Use a ruler to make it horizontal on the canvas. Then draw the rocks and waves. The bottoms of the rocks have the sea washing around them. In most cases, the rock bottoms will be level. Mix ultramarine blue, crimson and white for the upper portion of the sky. Add cadmium yellow and crimson for the lighter clouds. Make this color stronger—not as much white—on the right of the large rock. Paint the sky with a No. 12 nylon brush. Use gel retarder to paint wet-on-wet.

Second Stage—Paint the sea from the horizon to the large wave and rock. Use a No. 4 nylon brush to mix ultramarine blue, crimson, bright green and white. To the right of the rock, add more white mixed with a bit of cadmium yellow for highlights where the sunlight hits the breaking waves. Under the top of the large breaking wave, paint thin, watery ultramarine blue and bright green. This will produce the transparent look of the wave where it is thin. Now paint the dark shadow under the wave's forward edge. The lighter color is the foam floating under the forward edge. Here, the foam is in shadow. Paint the darker areas with ultramarine blue, crimson, bright green and a little white. Add the light foam by leaving dark areas and following the contour of the wave. Paint the side of the rock with burnt umber and bright green. Add more white to the wave color and paint the rest of the wave. Don't add too much white at this stage. Paint the water breaking over the large rock. Keep this in shadow. Start at the rock and work your brush up and away. Let the brush feel like spray bouncing off a rock. It will help your painting if you get excited about it.

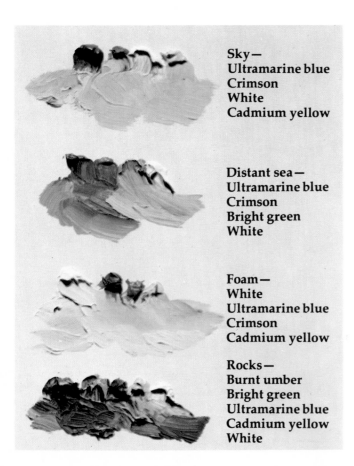

Sky—
Ultramarine blue
Crimson
White
Cadmium yellow

Distant sea—
Ultramarine blue
Crimson
Bright green
White

Foam—
White
Ultramarine blue
Crimson
Cadmium yellow

Rocks—
Burnt umber
Bright green
Ultramarine blue
Cadmium yellow
White

First stage

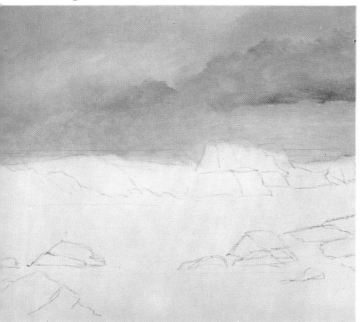

Second stage

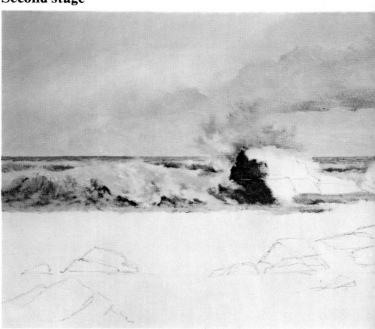

Third stage

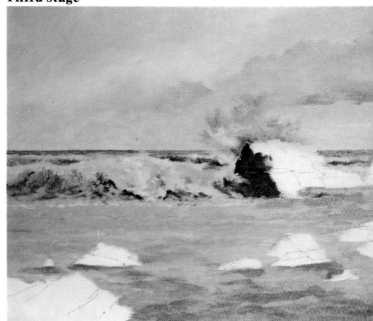

Third Stage—Now paint the rest of the sea. This area is first treated as an underpainting. It will have foam added over it. The rocks are unpainted at this stage. All the sides of the rocks except the bottom appear in front of the water. That is why it's easier to paint the rocks when most of the sea is finished. The rocks will have an edge as seen against the sea. Use a No. 8 nylon brush to mix ultramarine sharp blue, crimson, bright green and white. Paint the sea, starting from under the large wave and working across and down the canvas. Keep the brushstrokes horizontal so the water will appear level. As you come nearer the foreground, let the brushstrokes be less controlled. Add lighter and darker values and use the brush to form movement in the water. Don't be too critical of your work. Much of the same area will be covered in the next stage.

Final Stage—Now, paint the foam on the water. Use a No. 4 nylon brush with white, cerulean blue, crimson and cadmium yellow. Work the brush horizontally in short strokes, subtly changing the values and color all the time. Work on this part of the sea until the picture is finished. For the finishing touches on the foam, use sable brushes to paint the finer details. Next, work on the large, breaking wave. Use a No. 8 nylon brush loaded with white, a little cadmium yellow and crimson. Put the brush

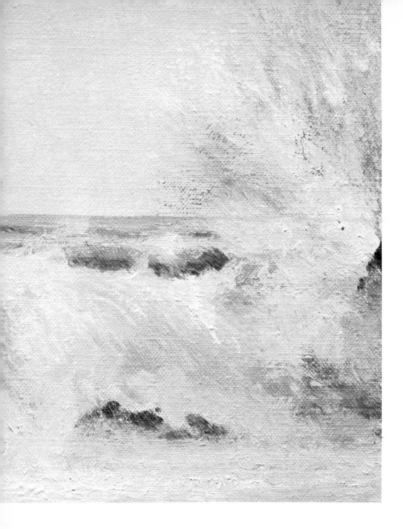

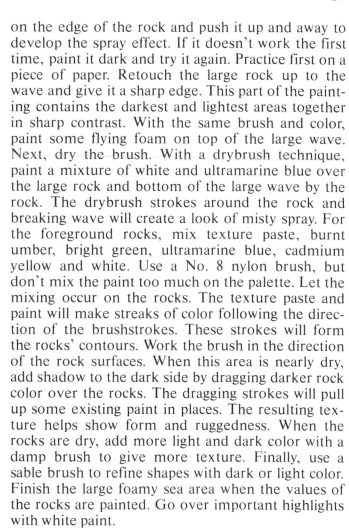

on the edge of the rock and push it up and away to develop the spray effect. If it doesn't work the first time, paint it dark and try it again. Practice first on a piece of paper. Retouch the large rock up to the wave and give it a sharp edge. This part of the painting contains the darkest and lightest areas together in sharp contrast. With the same brush and color, paint some flying foam on top of the large wave. Next, dry the brush. With a drybrush technique, paint a mixture of white and ultramarine blue over the large rock and bottom of the large wave by the rock. The drybrush strokes around the rock and breaking wave will create a look of misty spray. For the foreground rocks, mix texture paste, burnt umber, bright green, ultramarine blue, cadmium yellow and white. Use a No. 8 nylon brush, but don't mix the paint too much on the palette. Let the mixing occur on the rocks. The texture paste and paint will make streaks of color following the direction of the brushstrokes. These strokes will form the rocks' contours. Work the brush in the direction of the rock surfaces. When this area is nearly dry, add shadow to the dark side by dragging darker rock color over the rocks. The dragging strokes will pull up some existing paint in places. The resulting texture helps show form and ruggedness. When the rocks are dry, add more light and dark color with a damp brush to give more texture. Finally, use a sable brush to refine shapes with dark or light color. Finish the large foamy sea area when the values of the rocks are painted. Go over important highlights with white paint.

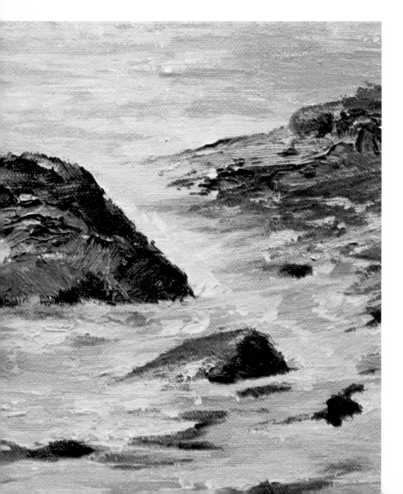

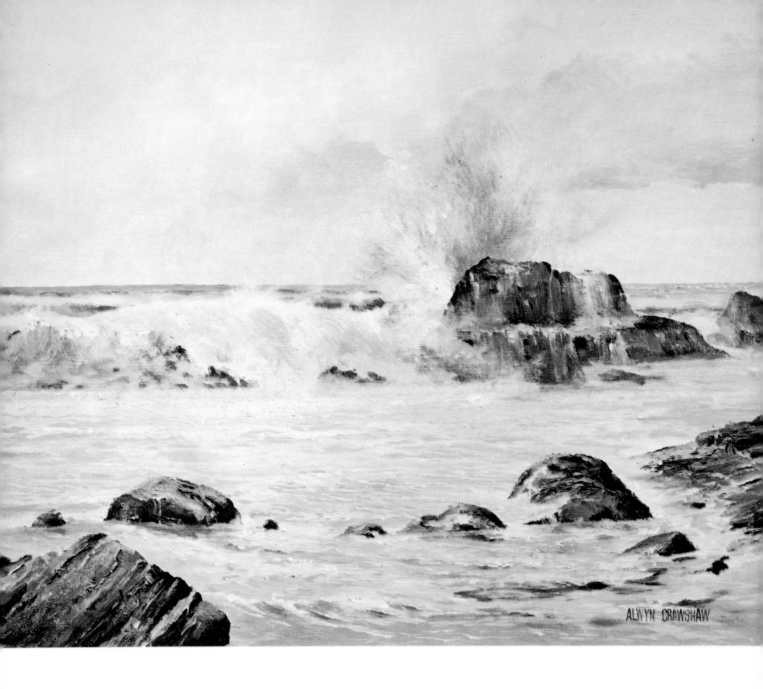

ALWYN CRAWSHAW

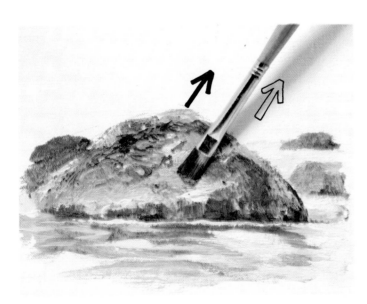

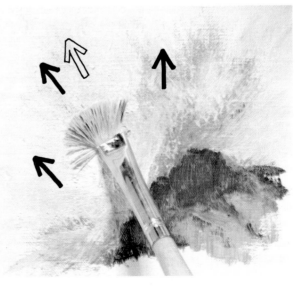

Painting Snow

Snow creates fascinating, moody scenes for an artist. The stillness and quiet of a snowy landscape can be dramatic and moving. Trees stand out in sharp silhouette. If you paint snow outside, you must accept and endure Nature's conditions. Put on more clothing than you think you need. Put your sketchbook in a waterproof bag so it will stay dry.

The most important guideline for painting snow is this: Never use just white paint for any part of the snowfall. Snow is only white in its purest form—just fallen. Even then, it reflects light and color from all around. So the "whitest" snow should have some color. Add a little blue to cool the white paint or a little red or yellow to warm it up. Never be reluctant to make snow *dark* in shadow areas. It can be as dark as a shadow in a landscape without snow in comparison to its surroundings.

Paint snow in a *low key*. Here's what low key means: Rank the darkest shadow as No. 10 and the brightest, whitest snow as No. 1, with an equal gra-dation of light-to-dark values in between. You should paint the snow in the low-key range from 8 to 3. This will leave enough reserves on both ends of the scale to add darker shadows and brighter highlights.

First Stage—Use an HB pencil to draw the landscape, starting with the horizon. Next, draw the edge of the main field, two main trees, the other trees and the river banks. For the upper portion of sky, use cerulean blue, crimson and white mixed with gel retarder. Halfway down the sky, paint a mixture of cadmium yellow, crimson and white into the still-wet sky. Then paint down to the horizon, adding more crimson as you go. The sky will have a lovely, luminous effect.

Second Stage—Paint the distant trees with cerulean blue, crimson, cadmium yellow and white. Use a drybrush technique. Add more white and paint the field underneath with a No. 4 nylon brush. Paint the house with the same brush but use a small sable brush for the chimneys. Put the highlight on the left of the house where the sun hits it. As in the landscape exercise, use drybrush strokes to paint the middle-distance trees and hedges. There is a warm glow in the sky because the scene is late afternoon. This mood should be reflected in the trees where the sun touches them. Use more crimson and cadmium yellow. Next, paint the snow on the lower field in the same way as the first one, but make it dark under the trees on the left. This area is in shadow. Now, paint the two main trees with a mixture of raw umber, burnt umber, bright green, ultramarine blue and crimson.

Third Stage—Paint the feathery branches on both main trees, using a No. 8 nylon brush in a drybrush technique. Mix cadmium yellow, crimson, raw umber and ultramarine blue. Next, use a No. 4 nylon brush to paint the hedge with cadmium yellow, crimson and ultramarine blue. Use a drybrush technique in upward strokes. Paint the water with a very watery mix of burnt umber, crimson and ultramarine blue. Use a No. 8 nylon brush loaded with water and paint. The paint will run down the canvas, which is what you want it to do. Keep the brush flat. Pull it down the canvas by starting each stroke at the top and to the side of the previous one. The brushstrokes will merge, producing a watery appearance. When the wash is dry, apply another wash over the top. Notice in the illus-

Sky—
Cerulean blue
Crimson
White

Bank—
Burnt umber
Cadmium yellow
Ultramarine blue

Snow—
White
Cerulean blue
Crimson
Raw sienna

Snow highlights—
White
Cadmium yellow
Crimson

First stage

Second stage

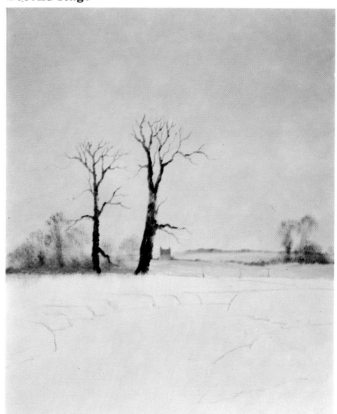

Third stage

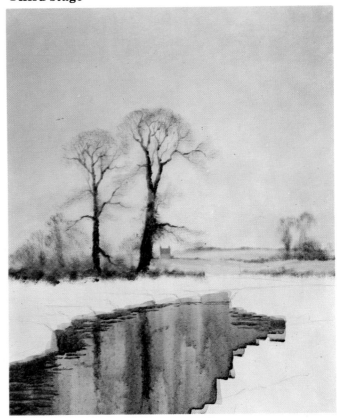

tration where the second wash was laid over the first one. The first wash appears lighter. When the second wash is nearly dry, paint reflections of the trees and bank, using a No. 4 nylon brush. Start under the bank and bring the brush down. The paint will mix slightly with the second wash, resulting in a soft edge. Don't try to paint many branch reflections. Now, paint the reflections of the river bank with horizontal strokes. Keep the paint watery.

Final Stage—Paint the bank on both sides of the river. Use a No. 4 nylon brush and a mixture of burnt umber, cadmium yellow and ultramarine blue. The white area left in the third stage will be snow. Remember to paint in a low key from 8 to 3 on the value chart. Start under the trees, using white, cerulean blue, crimson and raw sienna. Break up the line of snow under the hedge. Change values and colors of the snow as you go, working down to the river bank. Drag the brush over the bank and into the painted bank areas. With a No. 2 sable brush, paint the trunks of the middle-distance trees on the left. Use the paint thinly, working from the bottom of the trees up. With the same brush, paint the small branches of the large foreground trees, working downward. For the left tree, use warm colors because the sun is shining on it. Notice the small branches that have broken off and are in the hedge under the tree. Finish the reflections in the water, using a watery mixture of burnt umber, ultra-

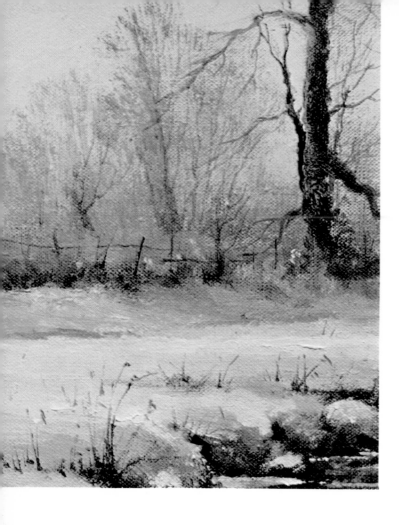

marine blue and crimson with a No. 5 sable brush. Repeat the wash over the area a few times to express movement of water over the reflection. When these washes are dry, paint the highlights with white, cadmium yellow and a touch of cerulean blue. Keep the brushstrokes horizontal. With a No. 4 nylon brush, mix snow-shadow color from cerulean blue, crimson, raw sienna and white. Paint the shadows on the left bank, running the paint slightly over the bank color. Now give sparkle to the snow by highlighting it. Mix white, cadmium yellow and crimson. Use a No. 4 nylon brush. Drag it in a drybrush technique over the sunlit areas. If you paint the snow in the right low key as I mentioned earlier, you will be surprised how "white" the highlights appear and how the snow seems to reflect light. Next, paint the gate and fence. Use a sable brush with raw umber, bright green and white. Finally, with a No. 2 sable brush, paint the winter grass and plants that show through the snow. They will add depth and perspective. Start your brushstroke at the bottom and work up and off the canvas. These must be confident strokes or they will not look real. Practice on paper first. Finish by adding light and dark accents.

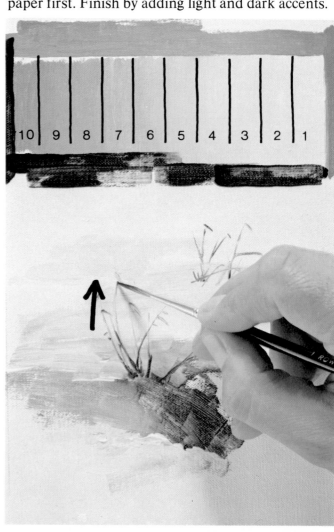

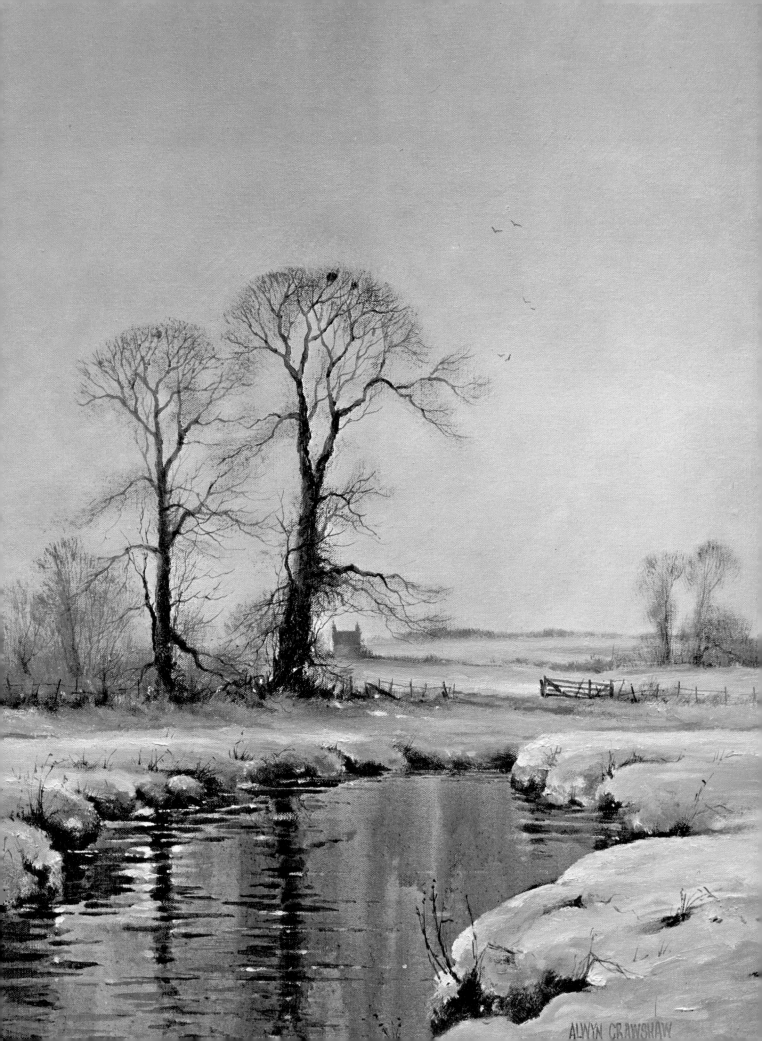
ALWYN CRAWSHAW

Painting Boats

We are back to the attraction of the sea again. Boats and the sea bring out similar emotions in us. But, I believe there is one difference: Boats make us feel we have some control over the sea.

In this painting of a British harbor, we feel the intimacy of the scene. The boats give a feeling of activity, while calm is conveyed by the still water.

More drawing ability is needed to paint boats than to paint a landscape. If a tree branch you are drawing is too low, it can still look realistic in your painting. But if a mast of a boat is leaning to one side, then the painting looks wrong. A few days spent sketching subjects in a small harbor—from old pieces of a shipwreck to a weathered link of chain—would give you a lot of familiarity with boats and their surroundings.

Sky, Water, Roofs—
Cerulean blue
Crimson
White

Red boat—
Cadmium red
Crimson
Burnt umber
White

Blue boat—
Cerulean blue
Crimson
Raw umber
White

Beach—
Burnt umber
Bright green
Crimson
Cadmium yellow
White

First Stage—I drew the harbor scene from a previous sketch. I had time to correct the drawing and make a careful study on the canvas in the studio. If I had painted outside, the drawing would have been less well-defined. I would have corrected it as I painted. First, draw the harbor wall. The bottom must be horizontal on the canvas. Next, draw the hill, a few of the main buildings in the distance and the middle-distance boats that have definite shapes. The other boats, which create the bustling harbor atmosphere, will be painted at random in later stages. Finally, draw the main boat and the smaller one on the beach. In this stage, the sky and water are the same color. Use a No. 12 nylon brush to mix cerulean blue, crimson and white. Paint from the top, well over the hill and buildings. Add more crimson as the sky disappears behind the hill. Continue painting over the water to the beach.

Second Stage—The hill behind the harbor was created by adding bright green to the previous colors. The rest of the buildings in this stage were painted in cerulean blue, crimson and white for the rooftops. Raw sienna, cadmium yellow, raw umber and white were added for the walls. It appears a lot of colors were used. But the real color is cerulean blue for the rooftops and raw sienna for the remainder. Other colors are added sparingly. It is the *variation of color and value* that gives a lively look to a painting. Use your No. 4 nylon brush to paint the hill, then the rooftops and lower parts of buildings. Don't try to make every building as I did. It is the *impression* of buildings that you want to portray. They are in the distance, so paint them in low key. With a sable brush, put in only enough detail to suggest windows and shutters. On the right of the picture, let the buildings merge to give an impression of distance. Paint the background showing through the boat cabin windows when painting the buildings. For the main fishing boat, use cadmium red, burnt umber, crimson and white. Add crimson to the shadow areas and white to the light parts. Start with the cabin, leaving the window frames. Then paint the hull. A No. 4 nylon brush was used for painting the hull plank by plank, starting from the top. At the stern of the boat, add white to the mixture where the sun highlights the wood. Paint over the red with a mixture of white, cerulean blue and crimson in spots where paint has worn off the boat. Then add cadmium yellow to the white in the cabin framework.

First stage

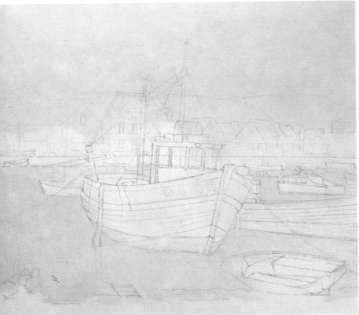

Second stage

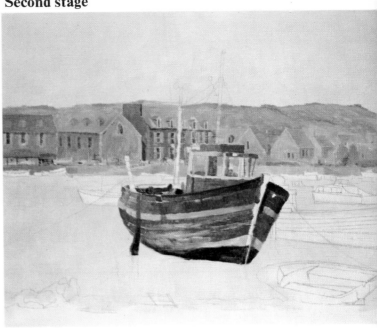

Third stage

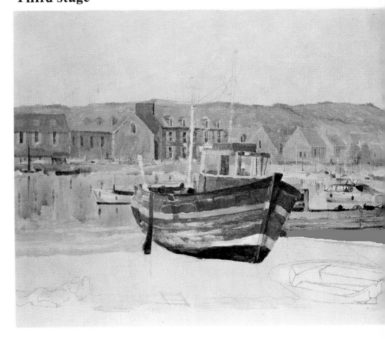

Third Stage—Use the colors you mixed for the buildings and a wet No. 8 nylon brush to paint the reflections. Start under the harbor wall, keeping the brush flat. Work downward, changing colors slightly as you paint along. Paint over the drawing of the boats. They will be repainted later. While the paint is still wet, put in reflections on windows. Now, paint the boats. The secret in creating an impression of a harbor busy with small craft is to keep them in the distance. Don't let other images upstage the main fishing boat in the foreground. Use white paint to mix colors for the boats. Select a No. 4 nylon brush and colors mixed with white. With light colors, paint oblong shapes to represent boats in the distance. Add dark areas such as cabins, ends of boats and other shapes. Paint some masts with a small sable brush. Make some light and some dark. Study the illustration and you can see that the only boats painted realistically are the cabin cruiser on the right and the bow of the yacht to the left of the red boat. These must be painted carefully to give the impression that all other shapes and masts in the distance are boats. A little more detail will be put in at the final stage. Now add the old boat on the right, just below the cabin cruiser. With a No. 4 nylon brush, paint the planks as you did on the red boat. Use cerulean blue, crimson, raw umber and white. When dry, drag over some darker paint in drybrush to give an aged look. Finally, paint the front of the bow on the red boat.

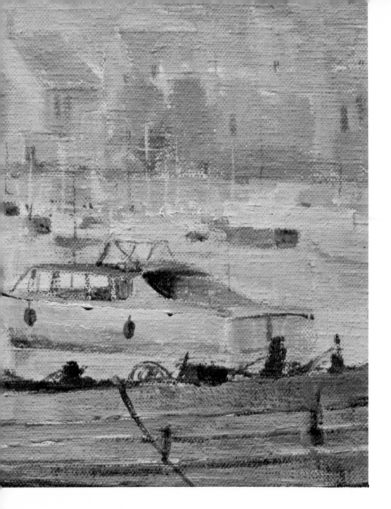

Final Stage—There are too many details to be added to describe them all. The important thing is to paint them with the right brush. Use a No. 4 nylon brush to paint reflections of the red boat and the old boat on the right. Make up a watery mixture of cerulean blue, crimson and burnt umber. Apply this wash down to the beach, adding cadmium red. Put on at least two washes. Then paint a dark shadow under the boats with ultramarine blue, crimson and burnt umber. Paint this shadow color up to and on the boats to merge the boats and water. Next, work the masts with a No. 5 sable brush. With this same sable brush, put lines on the red boat to indicate edges of planks and the shadow side of windows. Add more dark paint at the same time to the cabin windows. With a No. 2 sable brush, paint the lobster pot on the cabin in a dark color. Add lighter lines of raw sienna and white with the same brush to give it shape. Put a wash shadow to the right of the red boat's bow. Use ultramarine blue and crimson. Put the mast on the yacht to the left and darken the yacht's hull next to the red boat. With a sable brush, add the mast reflections. Paint the rigging lines with a No. 2 sable brush. Keep the paint watery. Now, with a No. 4 nylon brush, paint the small blue boat in the foreground, using cerulean blue, crimson, raw umber and white. Add ultramarine blue for the darkest shadows. Use the same brush to mix burnt umber, bright green, crimson, cadmium yellow and white. Add texture paste to the color mixture and paint the beach. When it is dry, add shadows and bits of old lobster pots on the left with a No. 3 sable brush. Put a dark shadow under the blue boat and on the beach. Darken the old boat with a thin mixture of cerulean blue, crimson and raw umber. Add cadmium red and white to the red boat to create a weathered look. Leave your painting at this stage. Come back later with a fresh eye to add final dark and light accents. This painting will take a long time if you put in all the details. Have patience.

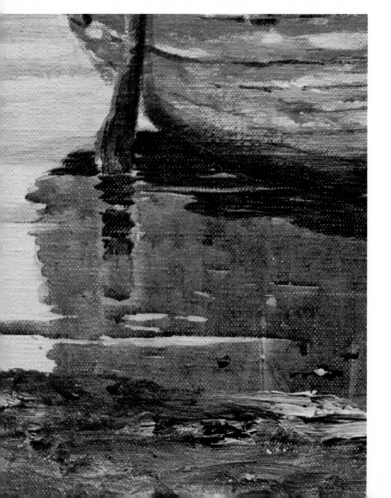

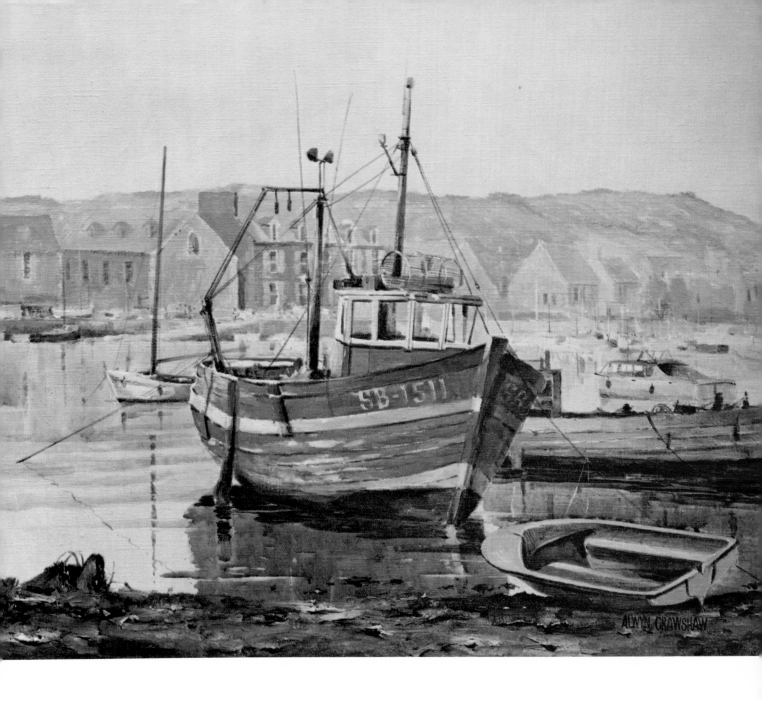

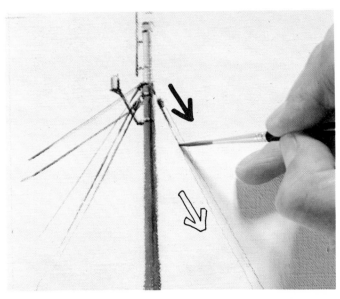

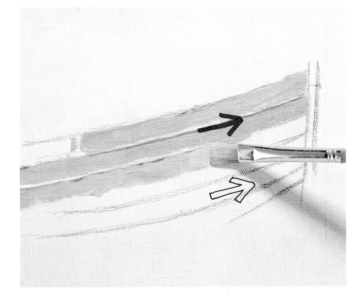

Painting A Portrait

Portrait painting has many advantages in common with still-life and flower painting. You can control lighting, color scheme and mood.

Portrait painting doesn't depend on the weather—only on the model's availability. You always have one model with you—yourself. All you need is a mirror.

Do some sketches first with a 3B pencil. Sketch your friends or members of your family. Study the light and shade that form broad areas of the face. Compare the relative positions of features. Look for distinguishing details—then slightly exaggerate them.

I sketch from the television to train myself to pick out the distinguishing features. The television allows no more than about 10 to 15 seconds and 15 to 30 pencil lines to sketch a general likeness. It's also very good practice for painting children, who seldom sit still.

Background—
Cadmium yellow
Ultramarine blue
Crimson
White

Light face tones—
Raw sienna
Cadmium yellow
Cadmium red
White

Dark face tones—
Raw sienna
Ultramarine blue
Raw umber
Cadmium red
Crimson
White

Cap, jacket—
Cerulean blue
Crimson
Raw umber
White

You can paint portraits without getting a true, photographic likeness. Portraits can come through as an impression or feeling. If you want detailed portraits, build up to them gradually through practice and careful observation.

First Stage—Draw the main features of the face. The eyeglasses are as important as the nose or mouth. Draw the cap next, and then the jacket. For the background, mix cadmium yellow, ultramarine blue, crimson and white. Paint the skin values on the face with cadmium yellow, crimson and burnt umber. Don't use white. Paint the skin transparently, using plenty of water.

Second Stage—Use a No. 4 nylon brush to mix raw sienna, cadmium red, cadmium yellow and white. Paint the light areas of the face, blending into the dark areas already painted. Mix raw sienna, ultramarine blue, raw umber, cadmium red, crimson and just a little white. Paint over the dark areas again, modeling the features. Blend into the light values. Replace ultramarine blue with cerulean blue, and paint the dark accents in the shadow area. Mold the eyes with a No. 5 sable brush. Whites of the eyes should be toned down since they are in shadow. Use cerulean blue, crimson, cadmium yellow and white. You will need some highlights to help with the shape. Put dark accents on the nose and lips. Add a little pure cadmium red on the lower lip to highlight it. The eyeglasses can still be made out under the paint. This is necessary because they help indicate the shape of the face. Now, mix cadmium red and crimson with glaze medium. Wash a No. 4 nylon brush thoroughly before you start. Apply the glaze mixture over the face to give it a unified, luminous appearance. The more you glaze, the more realistic the skin tones will appear. Add more whitish blue to the eyes where you went over the whites with the glaze. With a mixture of cerulean blue, crimson, raw umber and white, paint the beard and hair. Use a No. 4 nylon brush to put in the light skin tone on the right of the face, the forehead and cheek.

Third Stage—Paint the cap and jacket. Use broad brushstrokes, changing the values as you paint to create the look of cloth. Details will be added in the final stage. Mix cerulean blue, crimson, raw umber and white for the color. Light areas are almost all

First stage

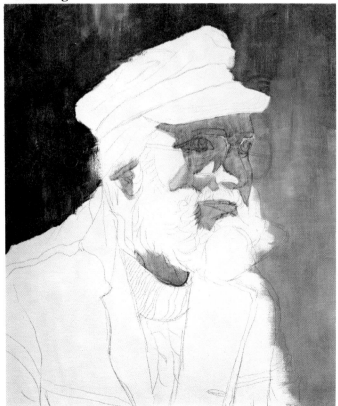

Second stage

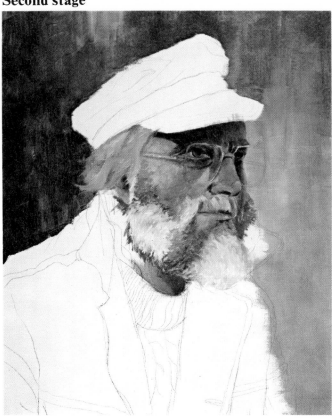

Third stage

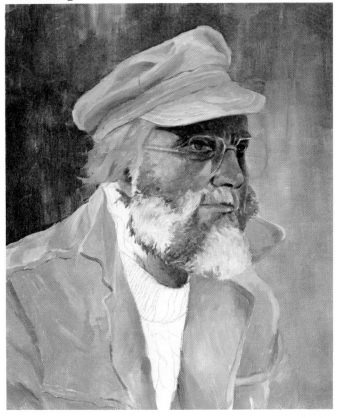

white, with a little blue added. Start with the cap. Let the brushstroke be floppy, using a No. 4 nylon brush. The only detail to put in now is the band between the visor and top of the cap. With a No. 5 sable brush, paint the dark and light lines around the band to suggest stitching. It also helps to give shape to the hat. For the jacket, use a No. 8 nylon brush. The only details required now are the seams and lapels. Accentuate these with a No. 5 sable brush, using light and dark color.

Final Stage—Paint the red collar. For the shadow area, use cadmium red, raw umber and ultramarine blue. The red not in shadow is pure cadmium red. Next, paint the sweater with a No. 4 nylon brush and a mixture of white, cerulean blue, crimson and cadmium yellow. With the edge of the same brush, put in the lines of the neck ribbing. Highlight the top edge of the neck to show the sweater's thickness. The beard has thousands of springy hairs. To create this effect, paint a few of the hairs. Using a No. 3 sable brush, paint from where the beard starts on the cheek and work down with short, definite brushstrokes. Use the following three values: Dark—ultramarine blue, crimson and cadmium yellow. Medium—same colors plus white. Light—nearly all

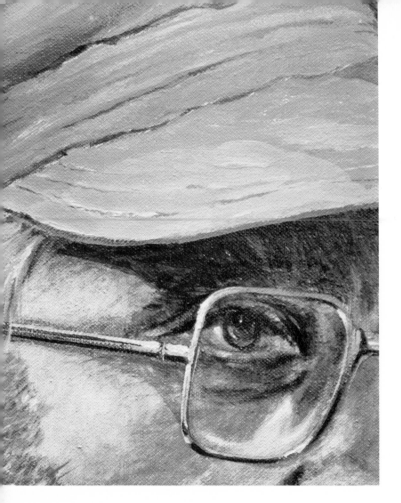

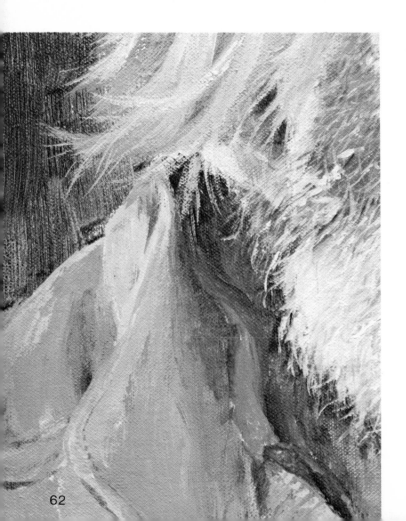

white. Use the brush with plenty of water to let the paint flow. Before you finish a beard, place some highlight hairs over dark areas, such as the neck shadow. Head hair is different from a beard. The hair is soft and long. Use a No. 5 sable brush to add more cadmium yellow to the lighter values you used for the beard. Bring the brush down from the cap in long, smooth strokes. Give the impression of hair, rather than painting single hairs. Paint the thin shadow under the hat, following the contours of the hair. Paint the glasses with a medium value all over the frames, using a No. 3 sable brush. Then add a darker value and some light touches. Add highlights next, using bits of flesh color in places to reflect the face. With the same brush, mix some watery white paint and paint the right lens from the top downward. This will give a shine to the glass. Do the same on the bottom of the other lens.

Finally, rest before looking at the painting with a fresh eye. Add those important light and dark accents. The jacket was kept simple to give the face more prominence.

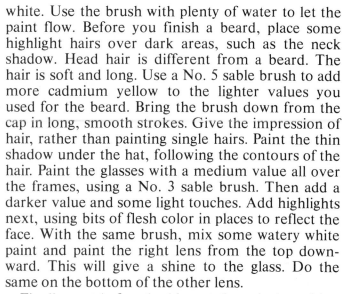

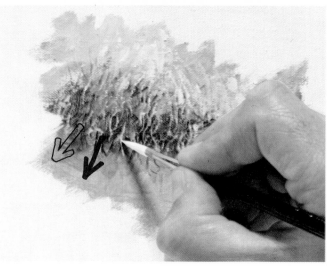

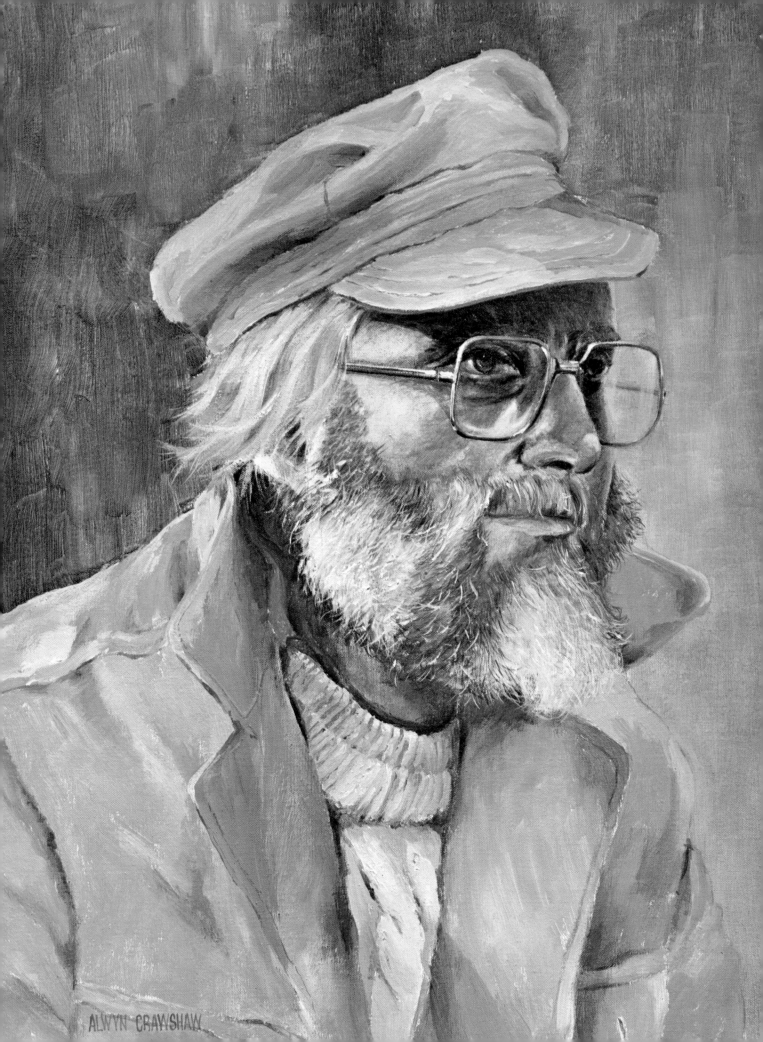

ALWYN CRAWSHAW

Points To Remember

- Always put the cap back on the paint tube after use.
- Keep nylon brushes in water when not in use.
- Always place colors in the same position on the palette.
- Be aware of values—the light-against-dark principle.
- Use the wet-on-wet technique for graduated washes. Add gel retarder if necessary.
- Use the drybrush technique for ripples, sparkles and highlights, especially on water.
- Always return your brush to water when not painting. Dry the brush well when you take it out.
- Spread paint thinly for transparent effects.

- Use texture paste for moldings, foregrounds, relief work and collage.
- Buy brushes of the best quality you can afford.
- Mix glaze medium with paint for transparent color. Try this technique for smoky effects.
- Don't use acrylic paint over oils.
- Don't mix different brands of acrylic paints.
- Relax. Practice as often as you can. Don't run before you can walk.
- Remember, observation is the key to good painting.

Index

6.4298357982